D0803420

Realist Drawings & Watercolors

Alfred Leslie
Self-Portrait, 1979
Graphite, 80x60 inches (four sheets of paper)
Allan Frumkin Gallery, New York

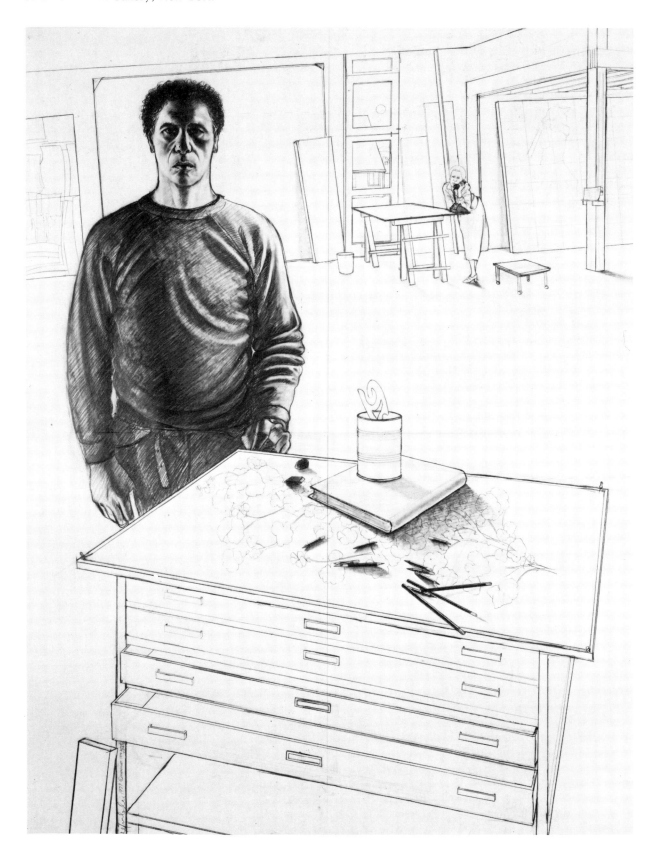

Realist Drawings & Watercolors

Alfred Leslie
Self-Portrait, 1979
Graphite, 80x60 inches (four sheets of paper)
Allan Frumkin Gallery, New York

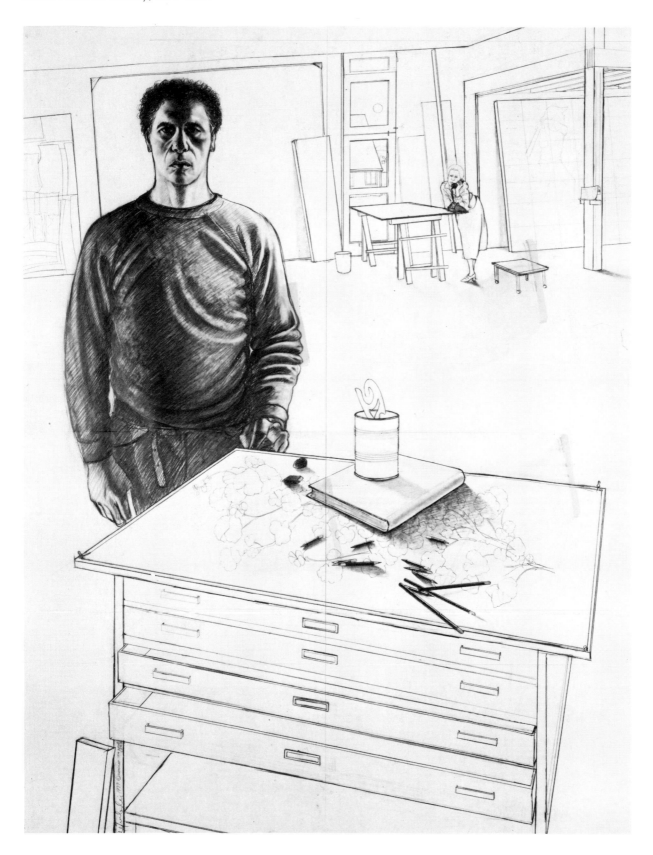

Contemporary American Works on Paper

Realist Drawings & Watercolors

John Arthur

SELKIRK COLLEGE LIBRARY

DISCARDED

APR 2 4 2022

DATE

New York Graphic Society/Boston

For Karen

Acknowledgments

A book of this kind is a collaborative effort. Assembling it has been like an intricate scavenger hunt with the clues and pieces coming from many sources, but I have not had to rely on the kindness of strangers.

I would like to thank all of the artists for their assistance and support. Some are close personal friends, some I have known for years, and most of us have worked together in the past. A few I have corresponded with occasionally, and some I have met as a result of research for the book. There have been many phone calls and letters to the artists, and they have been straightforward and generous in filling gaps in my information.

John Canaday has provided me with an admirable example of clearheadedness and independence. A long discussion over lunch with Irving Sandler helped sharpen the focus of the early chapters.

The dealers have been consistently helpful. Allan Frumkin has long been a friend and reliable adviser; he has taught me a great deal about looking at and thinking about works of art. Nancy Hoffman, Brooke Alexander, Robert Miller, the staff of the Fischbach Gallery, Ivan Karp of O. K. Harris, and other dealers have been extremely supportive in supplying transparencies, photographs, and information.

Betty Childs, my editor at New York Graphic Society, has dealt graciously, diligently, and delicately with my manuscript. Her assistance has brought the book to its present shape, which has not been a small task. I have relied on Jerome Schuerger's graphic design, judgment, and friendship for a decade, and he has given this book its elegant and appropriate form.

To all who have been involved, my gratitude and friendship.

J.A.

Copyright © 1980 by John Arthur

All rights reserved. No part of this book may be reproduced in any form or by any electronic or mechanical means including information storage and retrieval systems without permission in writing from the publisher, except by a reviewer who may quote brief passages in a review.

First edition

Designed by Jerome Schuerger

New York Graphic books are published by Little, Brown and Company

Published simultaneously in Canada by Little, Brown and Company (Canada) Limited

Printed in the United States of America

Library of Congress Cataloging in Publication Data
Arthur, John, 1939–
 Realist drawings & watercolors.
 Includes bibliographical references.
 1. Drawing, American. 2. Drawing — 20th century —
United States. 3. Water-color painting, American.
4. Water-color painting — 20th century — United States.
5. Realism in art — United States. I. Title.
NC108.A77 741'.092'2 80-23306
ISBN 0-8212-1102-1

DAVID THOMPSON UNIVERSITY CENTRE
LIBRARY
NELSON, B.C.
V1L 3C7

Contents

Wayne Thiebaud
Delicatessen, 1963–64
Ink, 24¼x20¼ inches
John Berggruen Gallery, San Francisco

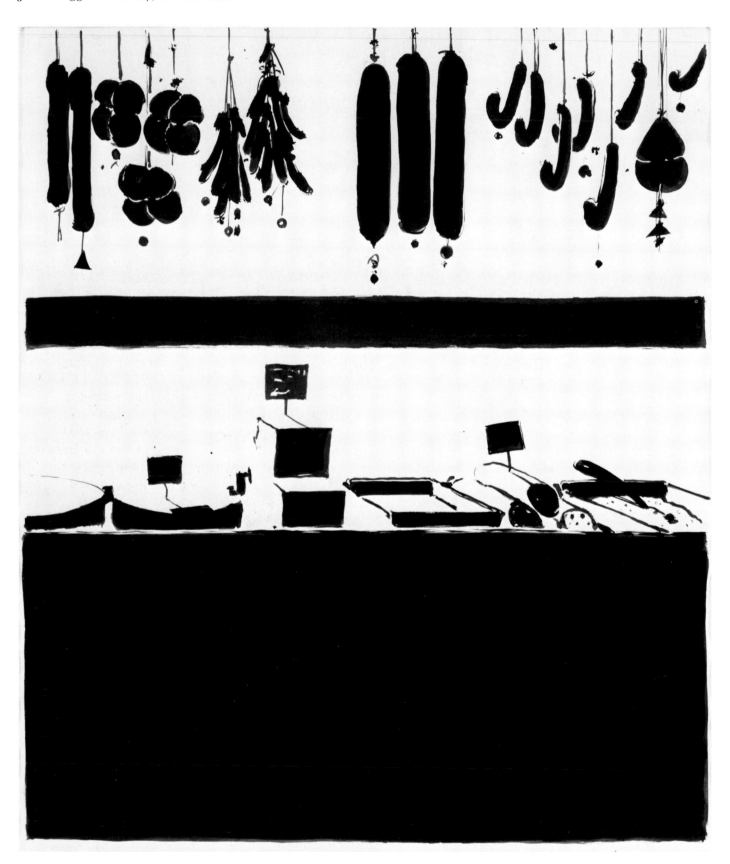

Introduction

Actually, that's the best part, pictures full of literature, rotten with anecdotes, that tell stories. . . .

<div align="right">Pablo Picasso[1]</div>

The period of the 1950s and 60s was one of the rare times in the history of Western art in which an influential and powerful segment of the art establishment regarded representational art with suspicion. These critics considered it to be retrograde, in spite of the towering exemplary works produced in the recent past, in Europe by Picasso, Matisse, and Balthus, among others, and in this country by Dickinson, Sheeler, O'Keeffe, and Hopper. Clearly, for a critic to argue that figural elements in the visual arts were "extra-aesthetic" contradicted the broad course of Western art and ignored great precedents in the twentieth century.

Today, after a long period dominated by abstraction, the signs of change are everywhere. Pluralism and eclecticism abound, and not only in painting and sculpture — witness the newborn impatience with modernist dogma in architecture. Awareness of and respect for a variety of recent and ancient forms of expression grow in all the arts. Yet much contemporary criticism is still tinged with formalist bias. It provides the wrong tools for looking at figurative painting and thus impairs the vision. Until humanist issues again dominate our critical consciousness, the basically formalist bent of contemporary criticism will continue to do injustice to post-modern art.

I believe that great art is inalienably anthropomorphic, and that the artist's visions and conceptions are perceived with greater strength and clarity when his or her art refers to the human situation.

That reference may take many forms under the mantle of Realism. And given the multitude of sources, past and present, from which contemporary art springs, it is important to note that what is referred to today as New Realism (or Photo-Realism, or Hyper-Realism, and so on) is in fact not new, but merely the most recent unfolding of the inexhaustible possibilities of Realism.

John Canaday has described Realism as "the representation of things and people as they actually appear. Realism does not rule out personal sensitivity and acute perception . . . but stops short of expressive or idealistic modifications or distortions."[2]

This book is an examination of contemporary Realism through drawings and watercolors. It is far from being a comprehensive survey and is not intended as such.

As always, there are questions of inclusions and omissions, and the choices are naturally the author's. For example, Andrew Wyeth is omitted, despite his technical skill as a draftsman, for I see his Republican view of rural America as stemming more from the tradition of illustration than of fine art. (I think he is, as someone has said of Rod McKuen, one of the most understood poets in America.) Larry Rivers is also absent, as his draw-

ings seem to be too much of a melting pot of ideas and expressive forms —
Abstract Expressionism, Pop, Painterly Realism — to work in the context of
this book. Some artists, such as Jim Dine, seem to have a different history
and sensibility from those that have recently begun to converge with the
work of the Realists. Others, Vija Celmins, for example, felt uncomfortable
about being placed in a Realist context, and it was her decision not to be
included. Many other figurative painters simply do not put much emphasis
on drawing, whereas I have chosen to include those for whom it is an
important act.

Drawing has a special importance for Realist art. If verisimilitude —
visual parallels with the visible world — is even a partial function of the
creative effort, the measure of the artist's success will hinge in part on
draftsmanship. Moreover, drawing, if for no other reason than its direct-
ness and the minimum of reworking it permits, is more closely aligned than
painting to the idea. Strengths, weaknesses, inflections, and emphasis are
more apparent in this form. As a shorthand for visual expression it pro-
vides many clues to the artist's thinking. "We can see a Holbein portrait
better if we have previously seen and learned by heart Holbein's drawings,"
said Wölfflin.[3]

To define drawing in a way that separates it from painting is a knotty
problem. For this volume, I have asked myself: "Would this go into the
print and drawing or the painting collection of a museum?" Medium,
ground, and size are the obvious factors, with a paper ground probably the
most general common denominator.

In *Twentieth-Century Drawings,* Una E. Johnson divided drawings into
three classifications:
1. The preliminary sketch for a painting, sculpture, and so on.
2. The unpremeditated sketch or drawing, including artists' sketch-
 books.
3. The complete compositional drawing, which may or may not have
 been intended as such by the artist.[4]

The drawings selected for this book are from the last category. Although
some relate to paintings, they are finished drawings.

It cannot be stated too strongly that this book is not a systematic survey
of Realism. It is, rather, an indication of works of the past decade, which is
traced through drawings and watercolors. These media have traditionally
served as the foundations for the transcription of the artist's ideas and will
always be at the core of "Realism."

1. Quoted in Dore Ashton, *Picasso on Art,* Documents of 20th-Century Art Series (New York: Viking Press, 1972), p. 161.

2. John Canaday, *What Is Modern Art?* (New York: Alfred A. Knopf, 1980), p. 374.

3. Heinrich Wölfflin, *Principles of Art History* (New York: Dover Pub., n.d.), p. 41.

4. Una E. Johnson, *Twentieth-Century Drawings, Part 1: 1900–1940* (New York: Shorewood Pub., Inc., 1964), p. 14.

Fairfield Porter
The Wall
Watercolor, 9x11¾ inches
Hirschl & Adler Galleries, New York

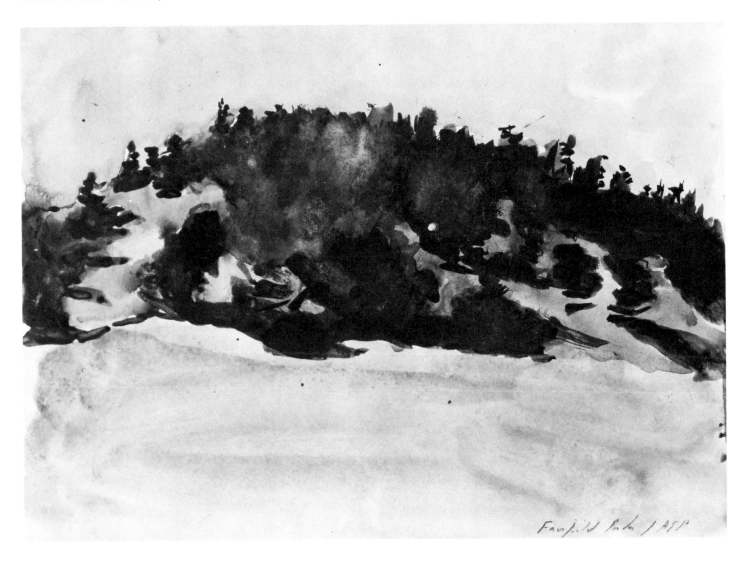

Richard Diebenkorn
Seated Nude, 1967
Ballpoint and ink wash, 17x14 inches
Collection Mr. and Mrs. Richard Diebenkorn,
Santa Monica

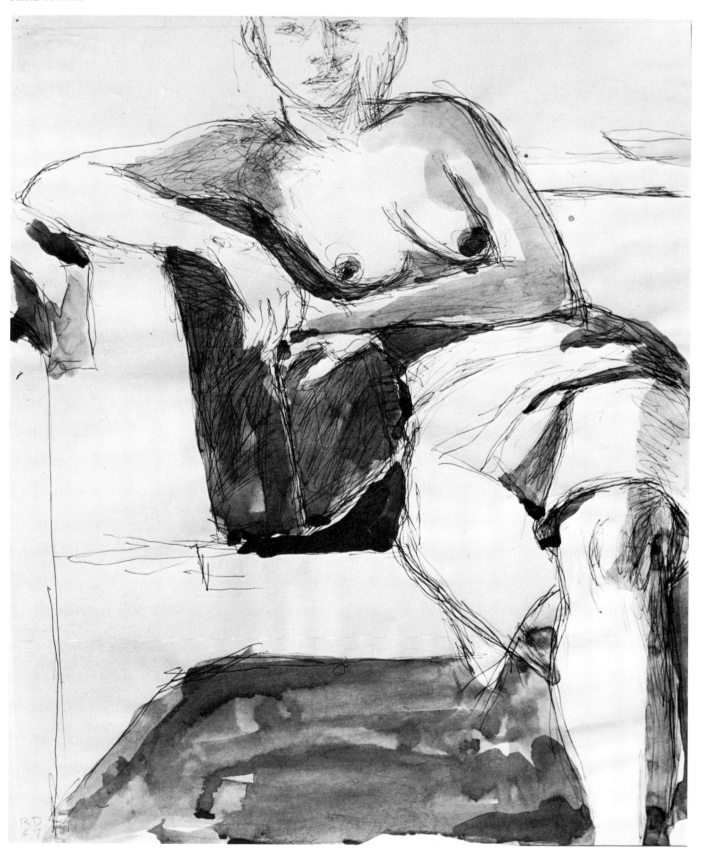

I

The Emerging Image:
East Coast, West Coast

The Trojan poet is dead. And now the Grecian poet will have his word.
> Jean Giraudoux, *Tiger at the Gates*

Interpretations of the past have always varied with the inclinations of the present. And certainly accounts of recent art history, which ought to provide a proper perspective for the present, are riddled with distortions as a result of what was omitted and what was emphasized.

For example, in the fifties and sixties the influence of photography on the other visual arts was seldom mentioned; nineteenth- and twentieth-century American art were only briefly discussed; and the range of expression and diversity in European painting was flattened by the heavy accent on Cubism and abstract art. Yet the figurative/narrative strain remained strong. In 1937 alone Picasso completed *Guernica,* his monumental protest of Fascism in Spain; Matisse executed his extraordinary *Lady In Blue*, and Bonnard painted the tranquil and tender *Morning: The Open Door.* Clearly, to insist that significance came only via Cézanne and Cubism revealed a narrowness that should be abhorrent to the creative spirit.

Whether out of bias or linear thinking, we were educated in the fifties and sixties to believe that the only valid, intelligent contemporary American art excluded figurative and narrative elements. In fact, those elements and symbolic references emerged frequently in the work of the Abstract Expressionists (de Kooning's *Woman* series of the early fifties, and Pollock's *Echo, No. 27,* painted in 1951, and his *Portrait and a Dream,* 1953, for example), and had a tremendous impact on younger artists like Alfred Leslie, Grace Hartigan, and Larry Rivers.

Irving Sandler succinctly appraises this period:

> Unfortunately, with the downfall of politically conscious styles, realist art went into an eclipse, at least in the eyes of the audience that favored advanced art. More than that, it was widely assumed that the creation of major new figurative styles, neither regressive nor provincial, was highly improbable, if not impossible. This belief was much more implicit than explicit, since the Abstract Expressionists whose art and/or ideas commanded most attention in the fifties — Pollock, de Kooning, Kline, and Hofmann — were painting pictures with recognizable imagery as well as abstractions. In fact, they strongly denied that one was superior to the other. But the reputations of even these masters were based primarily on their abstract work.
>
> To put it bluntly, abstract artists, unless they were obviously retardataire, derivative, or decorative, never had to worry about their art being minor, but purely figurative artists always did. This certainly was the case as late as the 1961–62 season in New York.[1]

In the ferment pervasive in the arts during the mid-fifties, two major figurative artists, Fairfield Porter and Richard Diebenkorn, emerged. As opposed to such figurative artists as Leonard Baskin and Ben Shahn, both vociferous in their verbal attacks on Modernism while coyly incorporating much of the "look" of the abstract art favored by the art press and many of the institutions, Porter and Diebenkorn clearly showed respectful, intelligent, and sympathetic assimilation of Abstract Expressionist concepts. They used them without deceit, fusing them with influences of the past and with their deeply personal and independent sensibilities.

Fairfield Porter majored in art history at Harvard, and after graduating in 1928 studied at the Art Students League with Boardman Robinson and Thomas Hart Benton. In this period he met Alfred Stieglitz and was influenced by his circle. By 1939 he had become acquainted with de Kooning and occasionally bought his paintings. At this time he also met Clement Greenberg. Porter's account of their relationship is described in Rackstraw Downes's foreword to *Fairfield Porter: Art in Its Own Terms,* a selection from Porter's critical writing:

> We always argued. We always disagreed. Everything one of us said the other would say no to it. He told me I was very conceited. I thought my opinions were as good as his or better. And he once said — I introduced him to deKooning — he was publicizing Pollock and he said to deKooning (he was painting the Woman), "You can't paint this way nowadays," and I thought, "Who the hell is he to say that?" He said, "You can't paint figuratively today." DeKooning's comment on this was, "He wanted to be my boss without pay." Porter's reaction was, "If that's what he says, I think I will do exactly what he says I can't do! That's all I will do." I might have become an abstract painter except for that.[2]

At Greenberg's request, about 1940 Porter wrote the first article on de Kooning, which was rejected by the editors of the *Partisan Review* and later by the *Kenyon Review.* Both considered de Kooning too obscure to merit space in their publications.

As a critic Porter was extremely perceptive and open-minded, and had a rare ability to approach and discuss works of art in terms of their inherent qualities rather than from a fixed aesthetic position. It is notable that his critical writings do not display much sympathy for the West Coast figurative artists, but Porter is important as a clear-eyed critic and as a highly respected and influential artist.

The distinct difference between Porter's and Diebenkorn's approach to subject matter must be pointed out, for the factors that separate them are crucial to the understanding of their work. Porter emphasized the character and physical appearance of a unique individual, interior, still life, or landscape. The image, rendered with economy, was edited but never generalized. His color is not arbitrary; it refers to the specific inflections of light. Formal considerations were emphasized over the more expressive factors.

Porter's work, unlike Diebenkorn's, lacks the grace and ease of an instinctive and natural artist; it is the result of a keen intellect and iron will. The easy, fluent quality in his best work resulted from tenacious effort

Fairfield Porter
Apple Branch, 1973
Watercolor on paper, 20x25 inches
Hirschl & Adler Galleries, New York

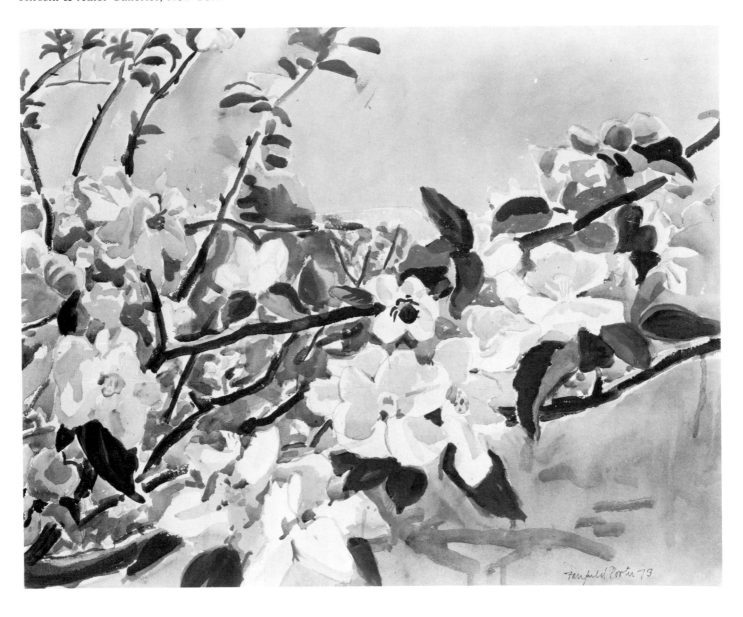

combined with a determination to cover signs of that struggle. Many of the drawings and watercolors, such as *The Wall,* have the quality of a private note, reminders of visual specifics loaded with nuance. There is a slight awkwardness about them. They are very much to the point, devoid of tentativeness, as were Porter's laconic conversations. Each is an explicit summation of a highly particularized subject; the silhouette of a tree, an apple branch, or the cliffs on the Maine coast (*Cliffs of Isle au Haut,* Plate 1).

Richard Diebenkorn, born in 1922 in Portland, Oregon, and raised in San Francisco, was enrolled at Stanford University in 1940, where he studied art with Daniel Mendelowitz and Victor Arnautoff. Mendelowitz had studied with Reginald Marsh and instilled in Diebenkorn an appreciation of Sheeler, Dove, and Hopper. In 1943 Diebenkorn entered the Marine Corps, and while in officers' training studied at Berkeley with Erle Loran, who passed down the aesthetics of Hans Hofmann. Later, while stationed outside Washington, D.C., Diebenkorn frequented the Phillips Collection. He recalls: "I looked at the paintings of Matisse, Picasso, Braque, Bonnard. . . . It was sort of an art school thing for me." Of particular importance was *The Studio, Quai St.-Michel* by Matisse; Maurice Tuchman describes this:

> Its appeal rests first in the candid way in which Matisse allows the viewer to see the artist's painting process. For example, he has not hidden the trial-and-error method by which he arrived at the eventual placement of the three whitish-gray paintings on the wall. Nothing is more characteristic of Diebenkorn's fundamentally empirical way of continually probing for visual correctness than what is implied in this passage. The emphatic contrast between indoor and outdoor space in the Matisse . . . must also have impressed the younger artist. This contrast, which allows a painter to emphasize the tangibility of space and evanescence of light, was deeply congenial to Diebenkorn, who would later fuse not only interiors and exteriors, but also still lifes with landscapes with figurative elements.[3]

Leaving the service, Diebenkorn returned to California, and in 1946 enrolled at the California School of Fine Arts, where David Parks was teaching. Parks became a teacher, mentor, and close friend. It was at this time that his relationship with Elmer Bischoff, John Hultberg, and James Weeks developed, and he was in contact with Mark Rothko, who was on the faculty.

Diebenkorn's abstract paintings of this period fused the influence of the Abstract Expressionists with the formal and structural elements of modern French painting via Matisse. These energetic, intuitive works with their sensual line, brushwork, and color brought him a broad and admiring audience. But around 1955 his painting moved from abstraction to figuration: "It was almost as though I could do too much too easily. There was nothing hard to come up against. And suddenly the figure paintings furnished a lot of this."[4]

The possibilities of painting representationally without expelling the formal and expressive aspects of abstraction were suggested by the works of David Park and Elmer Bischoff. Diebenkorn's intuitive and open-ended adjustments in the figurative paintings reveal the absence of a predetermined

Richard Diebenkorn
Seated Woman with Hat, 1967
Pencil and ink wash, 14x17 inches
Collection Mr. and Mrs. Richard Diebenkorn,
Santa Monica

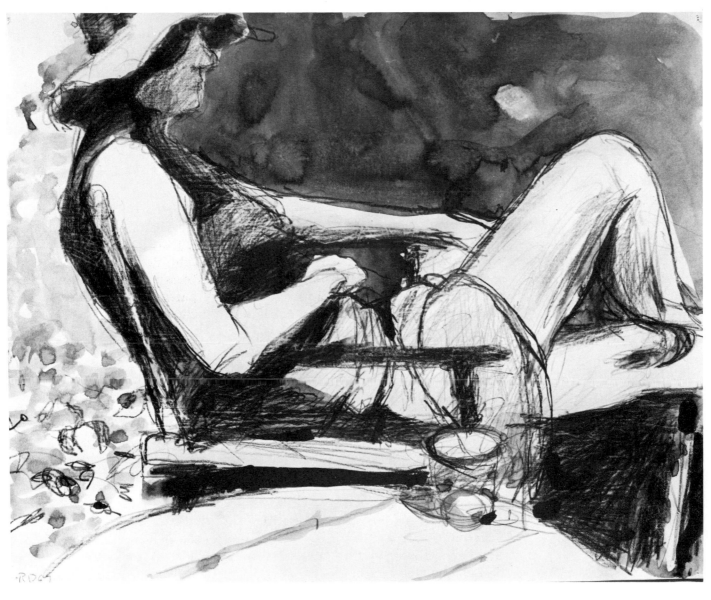

result, an approach that is reminiscent of the moves of Abstract Expressionism, or the way in which Matisse accomplished the metamorphosis of an image through progressively adjusted simplifications and refinements (as documented in the development of *Lady in Blue,* for example). This lack of plan, far from indecisiveness, is a chosen, informal methodology.

Diebenkorn's figurative drawings, which are the result of direct observation, are more specific than his figurative paintings. They are beautifully and judiciously composed on the page. His line, best seen in *Seated Nude,* is authoritative and on the mark, and the addition of the wash emphasizes the abstract qualities of the composition while simultaneously articulating the form.

Still Life/Cigarette Butts reaches back to earlier abstractions through the use of rich chiaroscuro, and the elaborate patterns of light and dark bring order to the random clutter of objects. In this drawing the tonal washes are used to unify the composition rather than to describe the volumetric qualities of the objects.

Although Diebenkorn returned to abstraction with his Ocean Park paintings in the late sixties, the influence of his figurative work is of major import for the realism of the sixties and seventies.

The drawings of Diebenkorn and Porter are similar in two ways: they are the result of direct observation, and they are free of affectation, so prevalent in the highly mannered figurative art of the fifties and sixties (for example, that of Leonard Baskin, Ben Shahn, Mauricio Lasansky, or José Luis Cuevas). The style, or look, of their drawings is the result of the convergence of personal vision, the inherent character of the medium, and economical editing of the "appearance" of the subject matter.

Diebenkorn's drawings and paintings reached a wider audience than did Porter's, and reverberations of his figurative work are seen today in the work of many younger artists. Porter's influence in the sixties was primarily through his independent and perceptive writing, and through his paintings; drawings and watercolors were not widely seen before the mid-seventies. Both men were major factors in making figurative art a viable, contemporary, and "post-modern," mode.

1. Irving Sandler, *Alex Katz* (New York: Harry N. Abrams, Inc., 1979), p. 57.

2. Rackstraw Downes, ed., *Fairfield Porter: Art in Its Own Terms — Selected Criticism 1935–1975* (New York: Taplinger Pub., 1979), p. 28.

3. Maurice Tuchman, "Diebenkorn's Early Years," in *Richard Diebenkorn: Paintings and Drawings, 1943–1976,* exhibition catalogue, Albright-Knox Art Gallery, Buffalo, New York, 1976, p. 6.

4. Quoted in Gerald Nordland, "The Figurative Works of Richard Diebenkorn," *Richard Diebenkorn: Paintings and Drawings,* p. 26.

Richard Diebenkorn
Still Life/Cigarette Butts, 1967
Pencil and ink, 14x17 inches
Collection Mr. and Mrs. Richard Diebenkorn,
Santa Monica

Philip Pearlstein
Model in Plum Colored Kimono on Stool, Both Legs Up, 1978
Watercolor, 59⅝x40¼ inches
Allan Frumkin Gallery, New York

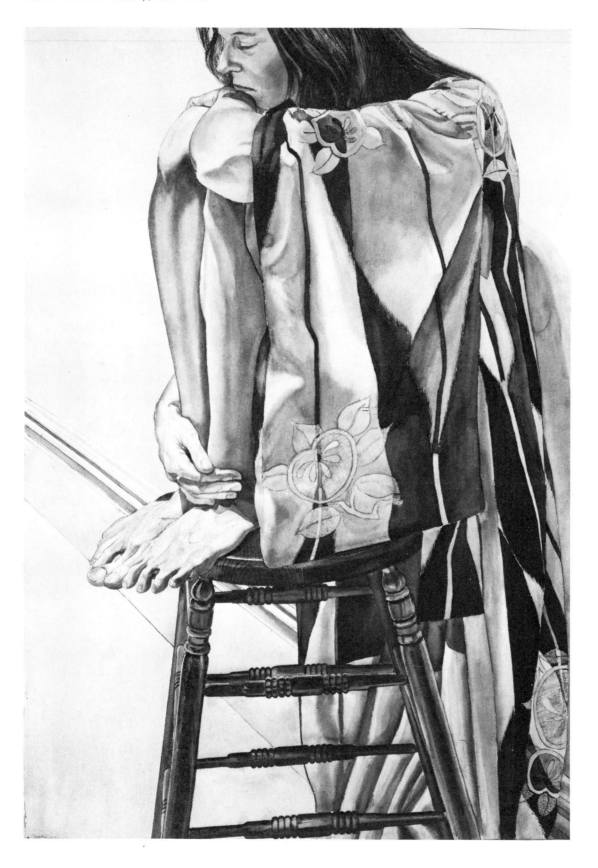

II

Realism:
The First Generation

When art is in trouble, realism comes to the rescue.
Stendhal

In considering contemporary Realism, several factors relating to the context and sensibilities that brought it to fruition should be kept in mind.

First, the work of the Realists of the first generation is based on direct observation, rather than on photographs.

Second, with the exception of Jack Beal (who was born in 1931), the members of the first generation are now over fifty years old. Their works and aesthetic positions are mature and firmly fixed. Most of these artists exhibited what are essentially Realist works in New York from the late fifties to the present. For some of this group, such as Pearlstein, Beal, and Leslie, the painterly aspects have become less emphatic in recent years, giving way to tactile description. Others, such as Welliver, Button, and Freilicher — closely associated with Fairfield Porter — or Thiebaud, more aligned with the West Coast figurative tradition, have remained "painterly realists," leaving much evidence of the hand.

Third, these artists admired and were influenced by the Abstract Expressionists, and most had direct contact with them. The first-generation artists were trained as abstract painters, and had a deep understanding of the ideas and aesthetics of abstraction. These "realists," like the "Pop," "formalist," and "hard-edge" painters with whom they were maturing simultaneously, explored various possibilities opened by the Abstract Expressionists.

Realism is not a development of the seventies. By the early sixties, what is commonly referred to as "New Realism" had been clearly formulated in the East and was being exhibited regularly in the galleries.

Porter described the situation in a review written in 1962:

> I believe that in American art, there can be no "return" to the figure. A movement toward painting the figure will be new, not renewed. It will be the first time American painters have tackled the problem directly. And there are in America today a number of artists who paint the figure without affectation, sentimentality or evasiveness, and who do not follow criticism, but precede it.

They preceded criticism because a majority of the critics, journalists, and institutions were looking the other way, out of personal preferences or vested positions. In the same clear-headed review Porter articulated the problem:

> As an editor of *Partisan Review,* Clement Greenberg took on art criticism as his specialty. In 1942 he promulgated the idea that it was impossible to paint the

figure any more. Presumably it had already been so thoroughly done that nothing new could be added — an important consideration to a critic allied to the principle of social progress. He thought the critic's role to be that of an especially competent interpreter of the Will of History. . . .

. . . the critical remark is less descriptive of what is going on than it is a call for a following — a slogan demanding allegiances. In this case criticism is so much influenced by politics that it imitates the technique of a totalitarian party on the way to power.[1]

The cohesiveness of Realism, like that of Impressionism, Expressionism, Cubism, and other art movements, is primarily a matter of time, geography, and certain links to the past. Beyond the similarity of subject matter, the high degree of verisimilitude derived from direct observation, and the artists' abilities as draftsmen, the relationships among the Realists are somewhat unpredictable, and at times tenuous and volatile. There are many demonstrations of extreme generosity and sincere encouragement, and there are numerous examples of pettiness, jealousy, and aesthetic quarreling. From a distance it is easy to assume the Realists shared an aesthetic position, but such philosophical factors often have less bearing on the art created than do renting proximate lofts, belonging to the same gallery stables, frequenting the same bars and restaurants, and feeling similar pressures for survival.

If one were able to define contemporary Realism in terms of its closeness to presenting objective, unadorned visual data, unencumbered by narrative or expressive inclinations, and distorted only by the qualities of medium and powers of optical perception, one would find Philip Pearlstein closest to the center. Pearlstein moved to New York in 1949 and shared living quarters with Andy Warhol, a classmate from Pittsburgh. Both worked as graphic designers, and that they shared some ideas is indicated by a painting of Superman by Pearlstein from the fifties.

Toward the end of the fifties Pearlstein moved from the large, rather expressionistic paintings of rock formations and landscapes he had been painting to studies of nudes posed in the studio. Over the years these paintings and drawings of nudes have tightened up, and it is these highly finished works that come to mind when one thinks of Pearlstein. His well-known nudes are never disguised in allegorical trappings, nor do they engage the viewer with clues to personal identity. We know nothing about them beyond their specific physical appearance. Flesh, anatomy, furniture, and fabric converge in abstract compositions of color, pattern, textures, shapes, and silhouettes; carefully modeled forms occupy a space articulated by three stationary lights. This row of overhead lights is used to facilitate Pearlstein's abilities of description rather than to create mood or drama. The sepia wash drawings and watercolors of nudes (Plate 2) differ from the large oils primarily in the character and use of the medium, the difference in ground, and size. Pearlstein describes his procedure:

I start to draw somewhere that gives me the most difficult juxtaposition of forms — usually I start with the hands. I draw the entire hand finger by

Philip Pearlstein
Temple at Abou Simbel, 1979
Watercolor, 29x41 inches
Allan Frumkin Gallery, New York

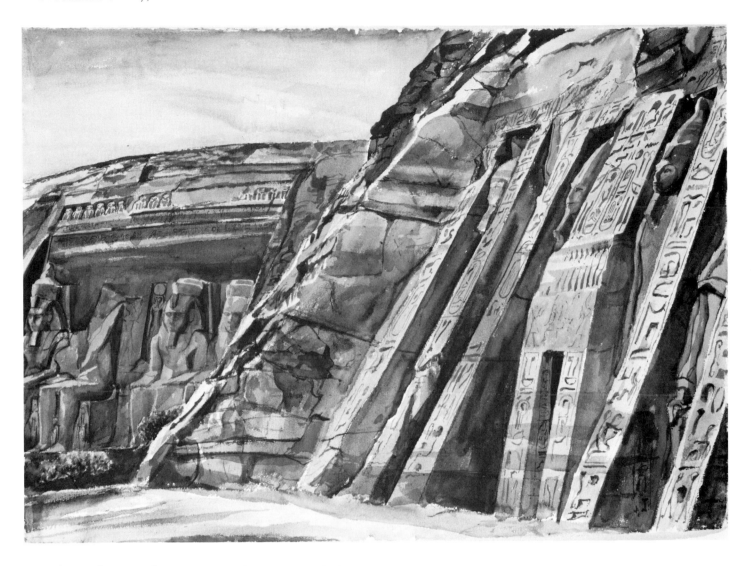

finger, wrinkle by wrinkle, and then go on to the next form. But the first form provides a module for the rest of the drawing: all successive forms are visually measured against it. I concentrate on drawing the contours of shapes, seeing them for the moment as flat areas. If I get the contours of all the shapes, including the shapes of empty spaces, correctly measured against one another, the drawing works itself out. I don't bother with proportions, anatomical knowledge, or foreshortening. Since my basic premise is that the figures are the main forms of my compositional structures, I see the arms and legs and torsos primarily as directional movements, their contoured areas as the major shapes on my page or canvas; it doesn't matter where they stop.[2]

The distortions of relative proportions in the figurative drawings and watercolors are the combined result of Pearlstein's method of scanning and working very close to the model (sometimes a foot or arm almost touches the easel or drawing table). As for Pearlstein's landscape drawings (there are very few recent landscape paintings), it is important to remember that

21

Alfred Leslie
Coming to Term #5, 1971
Graphite, 40x30 inches
Allan Frumkin Gallery, New York

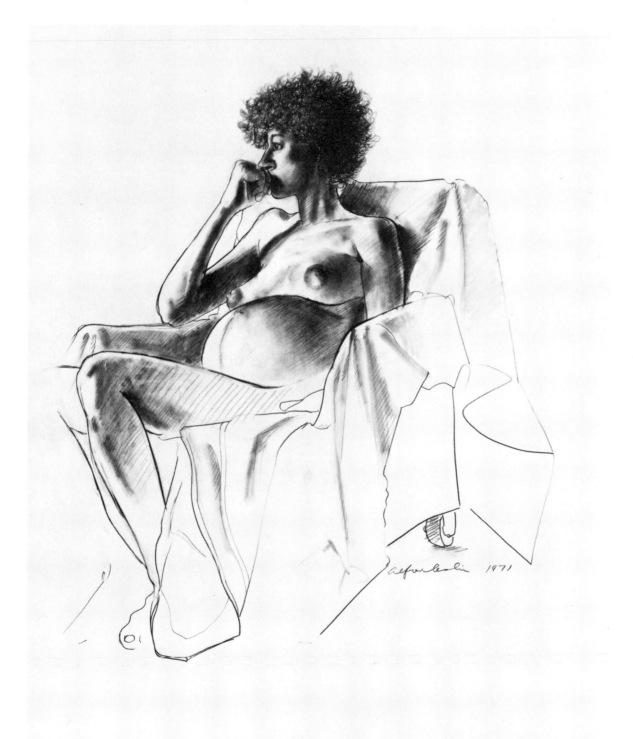

#5 "Coming To Term"

Alfred Leslie

The Nursing Couple #1, 1971
Graphite, 40x30 inches
Allan Frumkin Gallery, New York

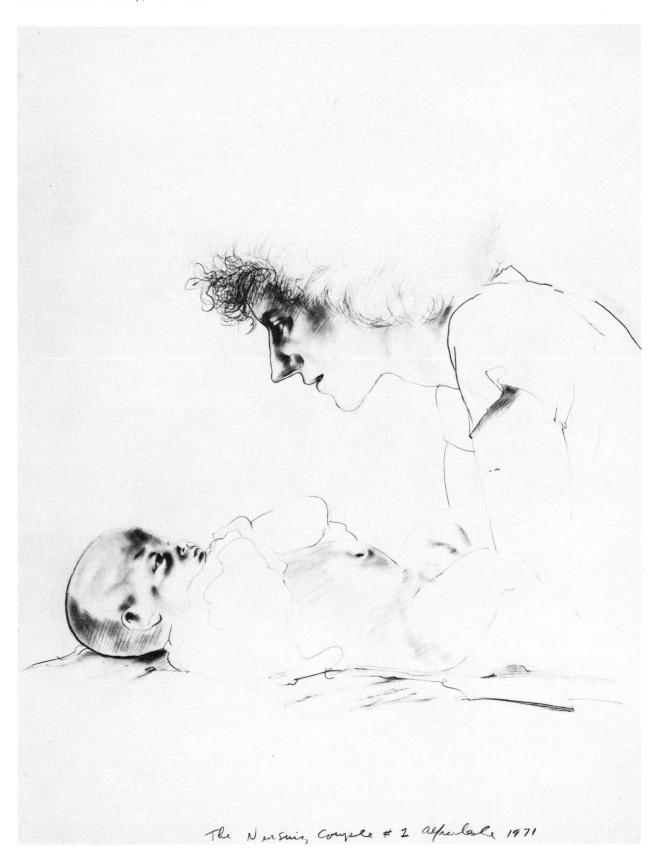

his earlier, more loosely rendered expressive works, which predate the well-known nudes, were of rock formations and Roman ruins. The recent watercolor landscapes of architectural or archaeological sites, such as *Temple at Abou Simbel,* testify to a recurrent interest rather than a new direction. Like the nudes, these monumental sites are observed directly, but there is a pronounced difference in their conception, arising from the enormity of the space as compared with the closed, somewhat cramped quarters of the studio, and also from a perpetually changing light moving across the surfaces as opposed to the static overhead lights casting a triad of shadows on the spaces around the figures.

While Pearlstein has sought to keep his figurative work free of any allegorical and story-telling references, a narrative element has long existed in Alfred Leslie's work. This was evident in his early expressionist collages assembled from studio litter; in his film work (such as *Pull My Daisy,* a collaborative effort with Robert Frank and Jack Kerouac, with Allen Ginsberg, Larry Rivers, and others assuming the roles of actors); in the monumental cycle of seven paintings produced over the last thirteen years, *The Killing of Frank O'Hara*; and in individual pieces like *7:00 A.M. News* and the *Birthday for Ethel Moore.* Among the strongest and most uncompromising examples of contemporary narrative art are Leslie's *Coming to Term,* a set of eleven drawings of his wife Constance, from the beginning of her pregnancy to the delivery room; and *The Nursing Couple,* which examines with subtlety and pathos the private moments in the physical and psychological relationship between mother and nursing infant.

These large drawings, done directly from the model, show Leslie at the height of his powers as a draftsman and clear-headed observer of the human situation. He uses the simplest of tools, a 4B pencil, eraser, and a smooth-toothed paper; the line is loaded with authority, and the smudged graphite describes light and form. What is not important to the narrative focus of each drawing is simply left out, recalling Matisse's dictum, "What does not add to a painting detracts from it."

In an interview with the author, Leslie summed up his attitude toward subject matter:

> I think there are truths in old people, truths to be seen in babies, nursing mothers, children, and family life. I may not be the one who is able to do it, but I think those subjects, inherently, are fine subjects. And if I can't do it, then I hope that some quality of the effort that I make can be passed on to someone else who may have a better way of looking at it, maybe with more skills, more analytical strengths to make convincing the values of everyday life, including family life.[3]

Alfred Leslie once remarked that Jack Beal was not a hard-core Realist but used appearance as an expressive guise. And indeed, whereas Pearlstein faithfully reproduces the exterior of things, Beal uses accurate rendering, coupled with complex compositions and carefully chosen accoutrements, to map the interior of his subject, merging physiological states and subtle emotional nuances. In regard to drawing, Beal has said:

Jack Beal
Portrait of Alfred Leslie, 1976
Charcoal, 25½x19⅝ inches
Allan Frumkin Gallery, New York

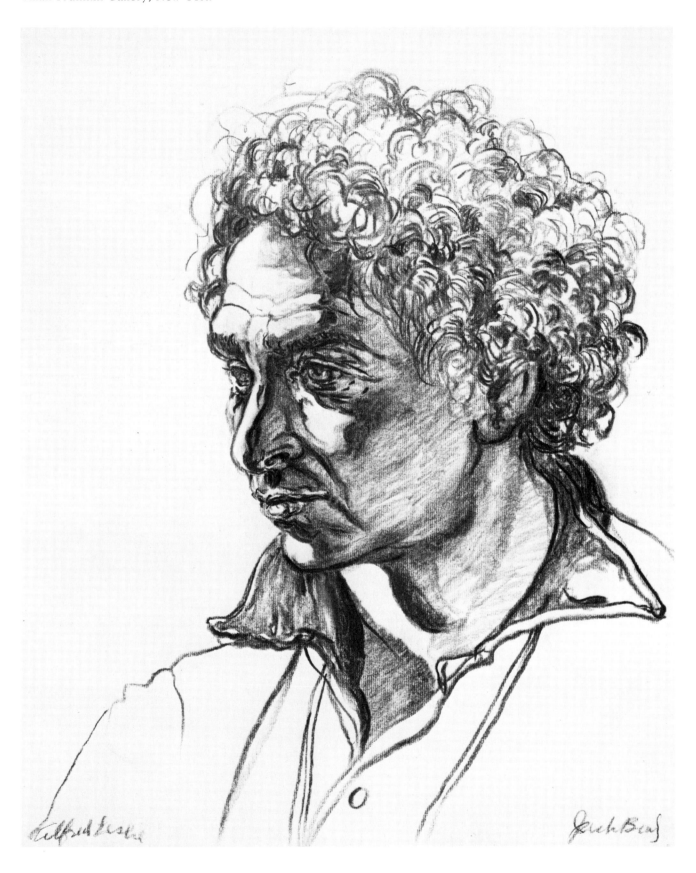

25

Jack Beal
Portrait of Mark Strand, 1973
Charcoal, 27⅛x19⅞ inches
Collection Indiana University Art Museum, Bloomington

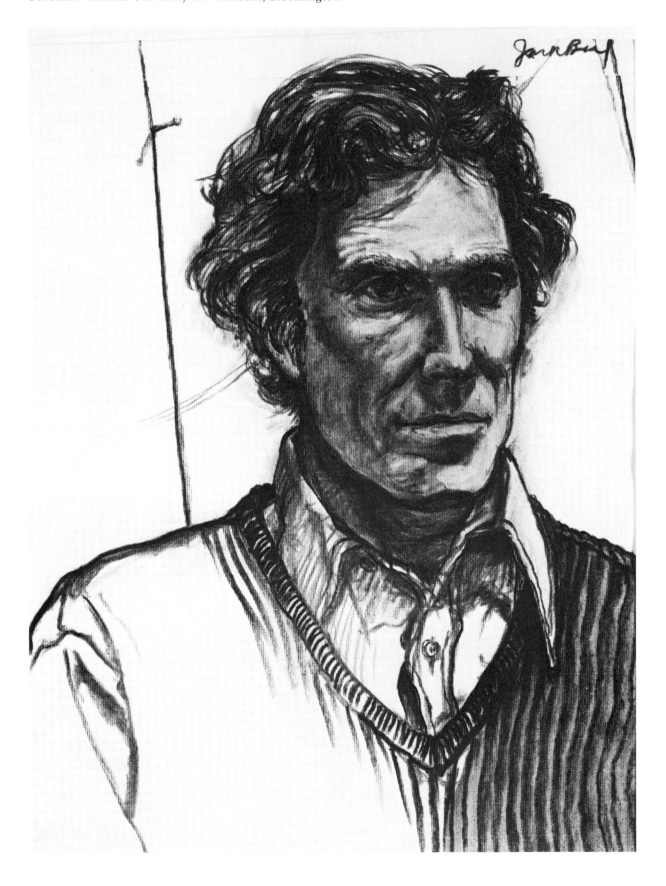

26

Drawing is very important to me. I draw for each painting — almost every head that appears in my paintings was first done from a model as a complete charcoal portrait. But besides, drawing gives me more satisfaction than anything else I do. It is my hobby, my relaxation.[4]

The best of Beal's portrait drawings are remarkable both as images and as astute observations of character and personality. The majority of these portrait drawings are done with vine charcoal, and they are usually completed in several sittings. The composition fills the sheet of paper; occasionally an extra strip is added as the drawing emerges, as in the portrait of Mark Strand, the poet. Lines appear and disappear, or are smudged to a tone; highlights are brought up with a kneaded eraser. When the drawing is finished, little sign of the struggle for likeness and for the desired aspect of personality remains. As in so many examples of great draftsmanship, the results seem to have been easily obtained.

Beal's pastels, usually worked up directly from the subject, begin with a line put down without error on the middle-toned gray paper, trailing across the sheet to describe a major edge, such as the contour separating the bank of trees from the sky. Other lines of other colors appear, squiggles that look as random as the wormholes on the inside of a piece of bark. There is no blending of colors on the paper, as usually practiced with pastel, and much of the effect is left to the tone of the paper, which becomes the middle value of elements of such disparate textures, densities, and colors as foliage, bark, stone, and water. The resulting image, such as *Waterfall* (Plate 3), while recording the appearance of the specific landscape, quivers between abstraction and realism, a distillation of information akin to that in a Japanese print.

By comparison, the large, handsome portrait paintings and prints of Alex Katz are cool and detached. They function superficially on Pop turf, with stylistic references to the simplified, snappy icons of advertising. The subject matter ranges from numerous images of Katz's wife Ada, son Vincent, and dog Sunny, to portraits of poets, artists, dealers, and friends, all glamorously editorialized and clearly dated by hairstyle, clothing, and trappings.

As a result of their bold design and delicately modulated tone and color, they are easily accessible, but they are difficult and somewhat perplexing in regard to other Realist works. The paintings, drawings, and prints are loaded with subtle moves, explorations of the expressive and formal possibilities, and are carefully refined images. It is a realism honed down to the essentials.

The drawings shown here illustrate Katz's stance on portraiture; his subjects become actors playing aspects of themselves, cast in roles devised and directed by the artist. The large self-portrait (this image has also been developed as a rich chiaroscuro aquatint and as a painting) wittily depicts the painter as a star and is reminiscent of the studio portraits of the movie idols of the forties. It seems to have been developed from the photograph of the artist reproduced in the series of "Artist Postcards," which is complete with autograph in red ink. But in fact the photograph, taken by Ada Katz, is based on the drawing.

Alex Katz
Self-Portrait, 1977
Pencil, 22x15 inches
Marlborough Gallery, Inc., New York

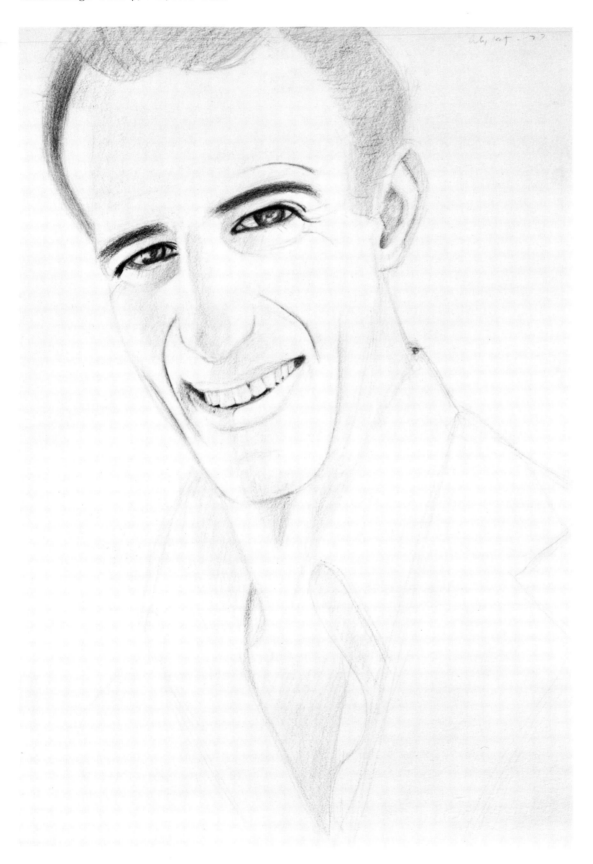

Alex Katz
Ada with Turban, 1979
Pencil, 20x15⅜ inches
Marlborough Gallery, Inc., New York

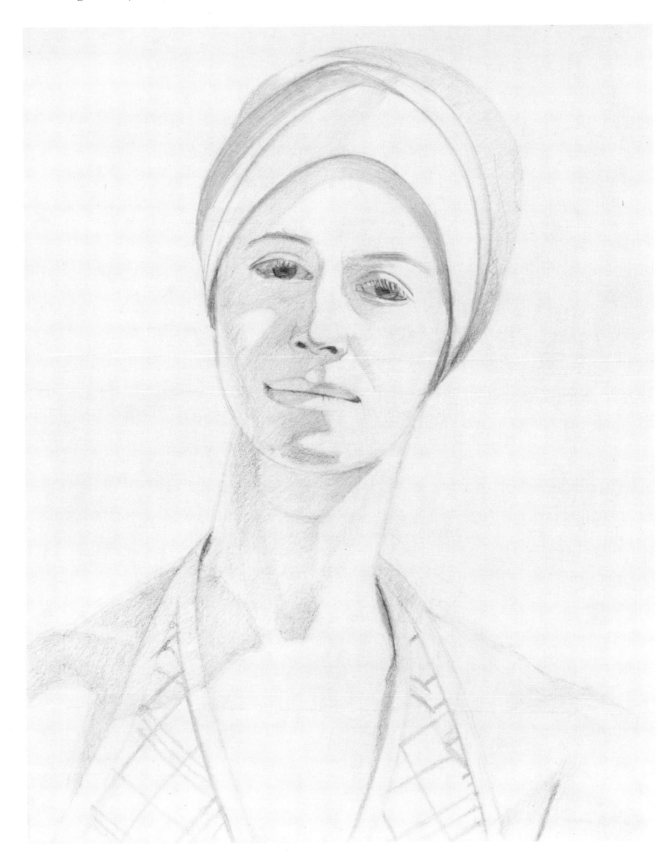

Ada with Turban clearly indicates the ever-shifting concentration on different facets of one subject. A poised, frontal portrait with the forms described by the light and cast shadows, it works well as a mate to the *Self-Portrait*.

The idea of image as icon is also characteristic of Wayne Thiebaud's work. In the early sixties Thiebaud was often inappropriately associated with Pop art because of his choice of subject matter — an unfortunate association in that it placed his work in the wrong context and suggested limitations that did not exist. Unlike the mechanical, graphic Pop images, Thiebaud's paintings and pastels are marvelously lush and sensual in both their painterliness and rich color.

Double entendres and visual puns abound. Rows of food, as in *Buffet* (Plate 4), pose like fantastic floats in a homecoming parade; surreal shapes in confectionery colors are rendered with pastel or paint that parallels the tactile surfaces it imitates. As in *Candy Ball Machine* and *Delicatessen,* the objects, which are usually drawn from memory, advertise themselves. These drawings refer with charm and humor to the society that consumes them, and to the ironic and surreal world of Dada. We are always caught off-guard by Thiebaud's subjects and are drawn into a reexamination of their counterparts in our daily life.

Like Wayne Thiebaud, John Button is a colorist. His color is subtle, controlled, color that never sacrifices form or tone, and that never strays far from the local visual fact; nevertheless, he is a colorist. Color is both expressive and descriptive when fused to an image, and the capabilities of a colorist are best illustrated in the refinement and subtle shifts of closely related values (Plate 5).

Button's small gouaches are directly rendered and swiftly achieved with what appears to be a minimal effort. The forms are solid, but the light is caught at a transitory moment. Fact is never labored beyond describing the inherent quality of the particular subject.

Jane Freilicher studied with Hans Hofmann and relates to the group of painterly realists that includes Fairfield Porter, Neil Welliver, Button, Nell Blaine, and Jane Wilson. She was with the Tibor de Nagy Gallery in the mid-fifties, along with such artists as Larry Rivers, Robert Goodnough, Alfred Leslie, Grace Hartigan, and Porter. Her work has a freshness and spontaneity that seem to indicate more interest in the pleasures of observation and the act of painting than in aesthetics. Painting and drawing seem to be a natural function.

Freilicher's impressionistic pastels are rich and clean in color. She sums up quickly and does not linger on specifics, and has an understanding of the inherent propensities of media, probably gleaned from abstractionist training. The pastel lines and patches of color, devoid of shape or form when viewed in isolated parts, become glass, flower, field, and sky only when totaled up as an image. Clearly, they become the sum she was after.

In the early seventies, the subject matter of Neil Welliver's large paintings was divided between figures (including voluptuous nudes in mountain streams) and landscapes of northern Maine — deep vistas or closed, dense woods, marked by seasonal changes, all painted with great bravura. In the

later seventies he worked almost exclusively in landscape. During the past decade his acclaim has spread, and today Welliver is widely considered to be the most significant contemporary landscape painter. The scenic splendors of New England — so often reduced to predictable and unconvincing pap by mediocre painters — resound with authenticity and authority in his paintings because he is not a sentimental tourist passing through the landscape. Welliver is keenly intelligent, highly informed, and very much a part of the land he paints, deeply committed to the protection of the environment and natural resources.

Many small oils are painted on location; the larger paintings are usually worked up in the studio from the smaller paintings. Welliver had abandoned watercolor for many years and returned to the medium circuitously only recently through hand-colored prints (these were published by Brooke Alexander). As with the watercolors of Pearlstein, they differ from the oils primarily in the transparency of the medium, which is used with the deftness of Winslow Homer (Plate 6).

1. Downes, ed., *Fairfield Porter*, pp. 72–73, 70.

2. *Philip Pearlstein, Zeichnungen und Aquarelle, die Druckgraphik,* exhibition catalogue, Staatliche Museen Preussischer Kulturbesitz, Kupferstichkabinett, Berlin-Dahlem, 1972, p. 14.

3. "Interview: Alfred Leslie Talks with John Arthur," *Drawing* 1, no. 4 (November-December 1979): 85.

4. *Allan Frumkin Gallery Newsletter*, no. 7 (Winter 1979): 5.

Wayne Thiebaud
Candy Ball Machine, 1977
Gouache and pastel, 24x18 inches
John Berggruen Gallery, San Francisco

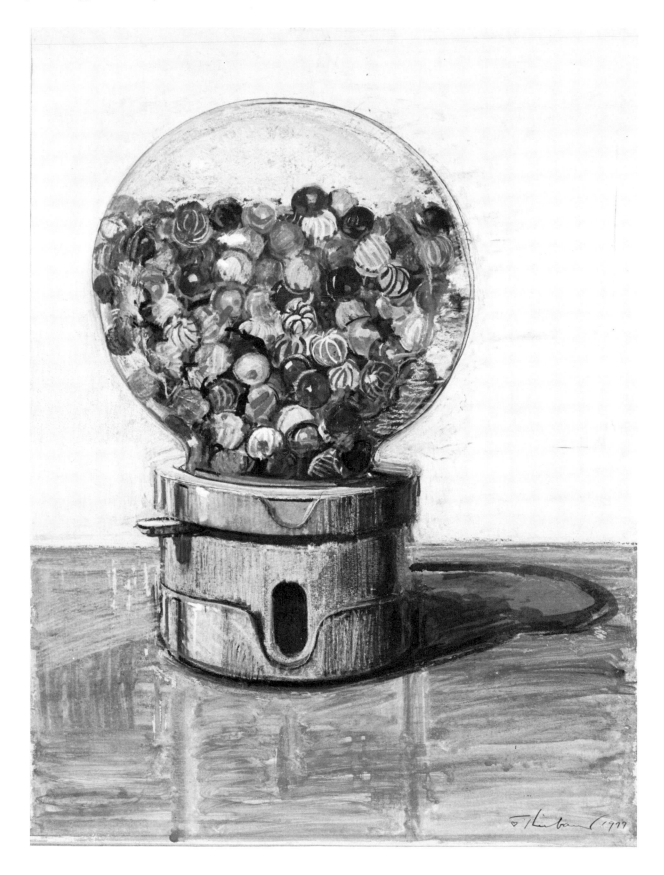

1 Fairfield Porter

Sketch for "Cliffs of Isle au Haut," 1974
Watercolor, 26x22 inches
Private collection

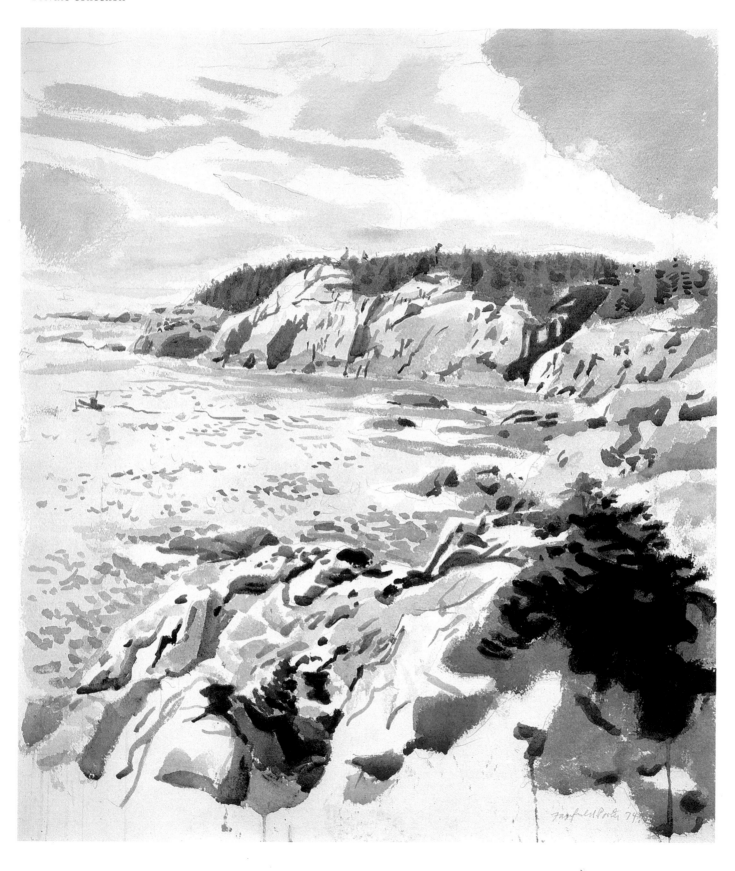

DAVID THOMPSON UNIVERSITY CENTRE
LIBRARY
NELSON, B.C.
V1L 3C7

2 Philip Pearlstein

Two Female Models on Chrome and Wooden Stools, 1979
Watercolor, 59¾x40 inches
Allan Frumkin Gallery, New York

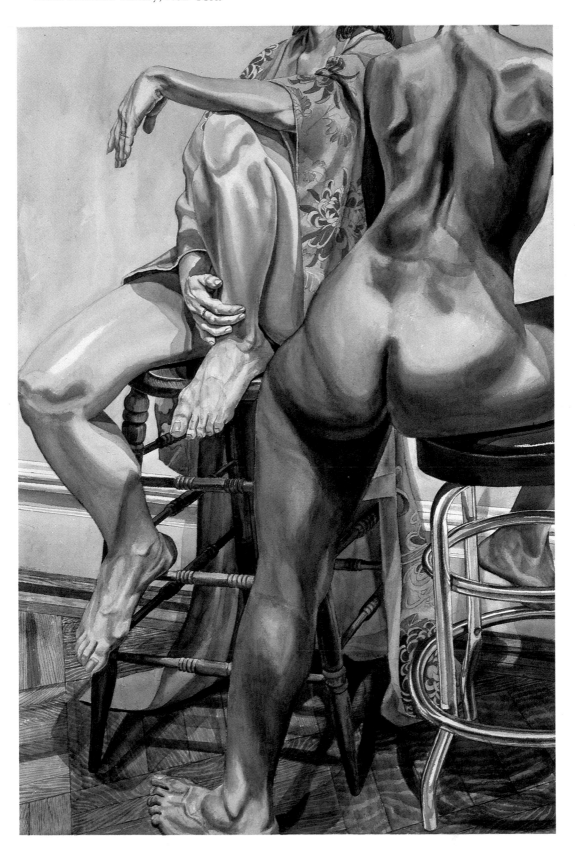

3 Jack Beal
Waterfall, 1979
Pastel on gray paper, 47½x47½ inches
Allan Frumkin Gallery, New York

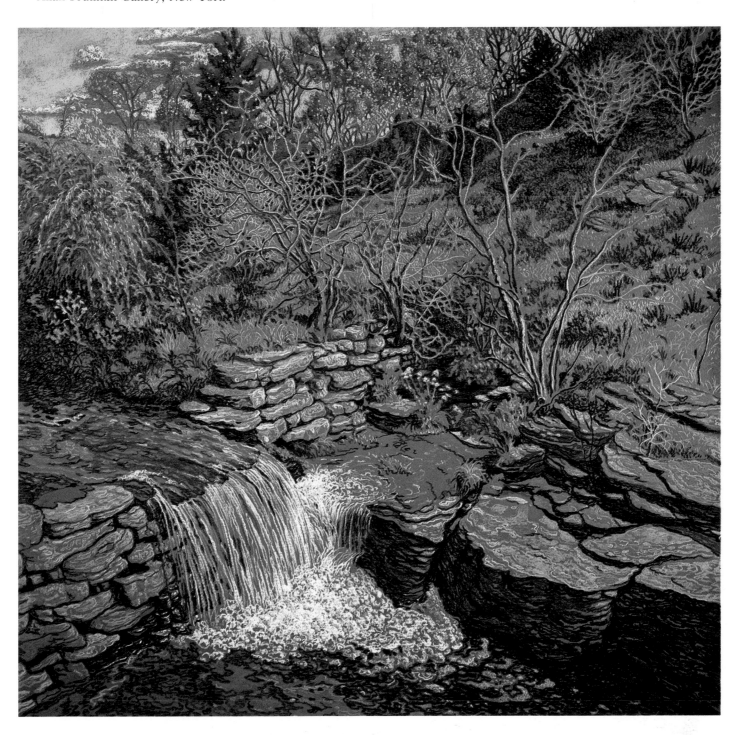

4 Wayne Thiebaud
Buffet, 1976
Pastel, 16x20¾ inches
Allan Stone Gallery, New York

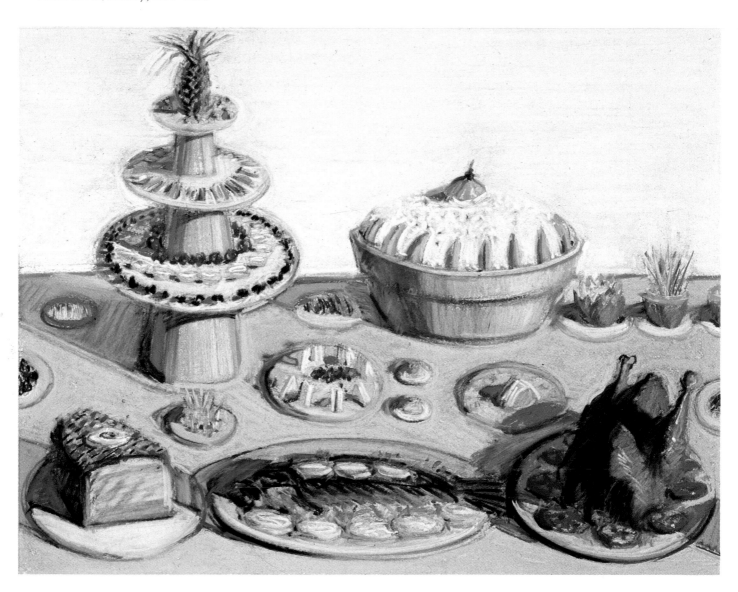

5 John Button

Green Cottage, Venice, California, 1976
Gouache, 14⅛x20 inches
Fischbach Gallery, New York

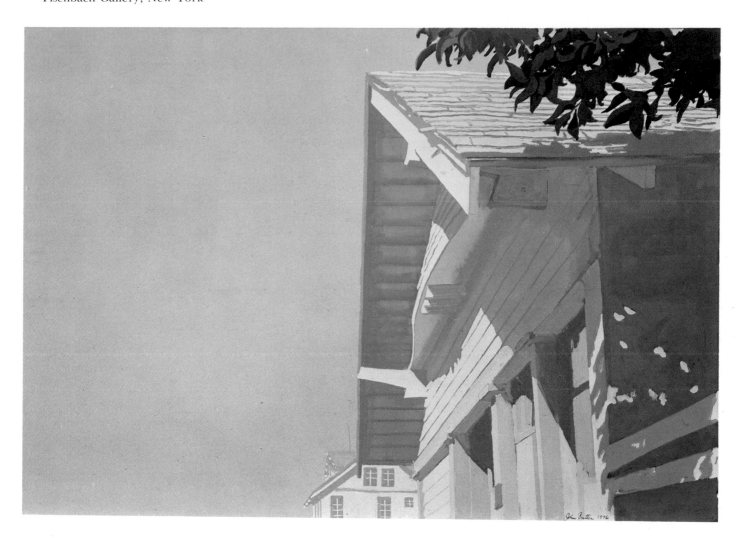

6 Neil Welliver

Reflection, 1977
Watercolor, 30x30 inches
Collection J. and R. Davidson, Boston

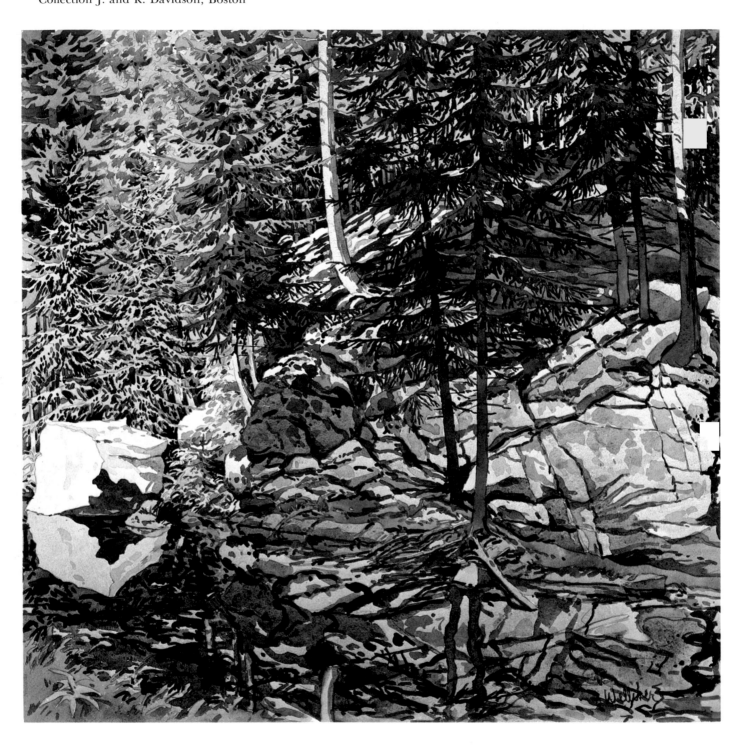

7 Richard Estes
Bridge, 1974
Gouache, 16x17 inches
Allan Stone Gallery, New York

8 Ralph Goings
Diner Still Life, 1977
Watercolor, 11x11 inches
O. K. Harris, New York

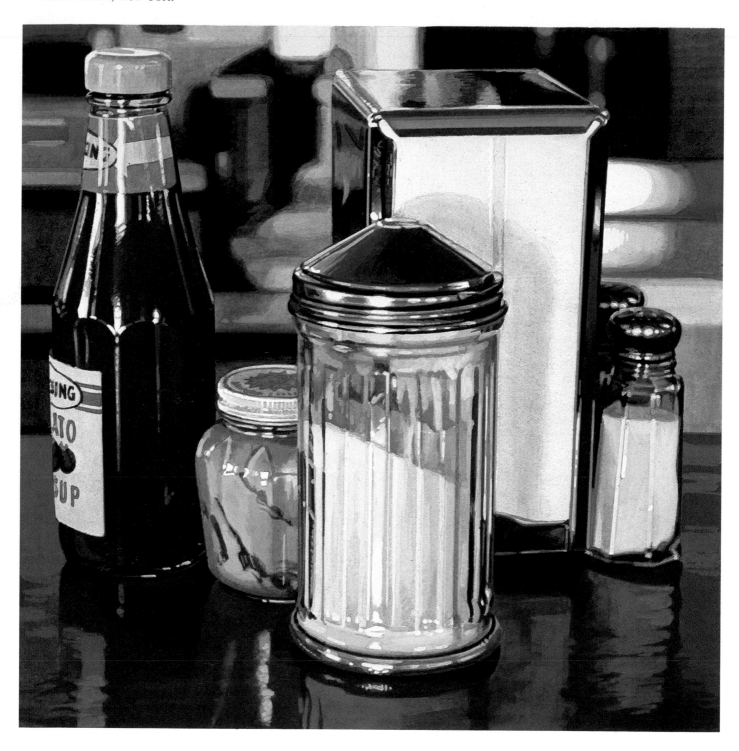

9 Robert Bechtle
'68 Cadillac, 1975
Watercolor, 10x15 inches
O. K. Harris, New York

10 John Baeder
Berkshire Diner, n.d.
Watercolor, 15½x22½ inches
O. K. Harris, New York

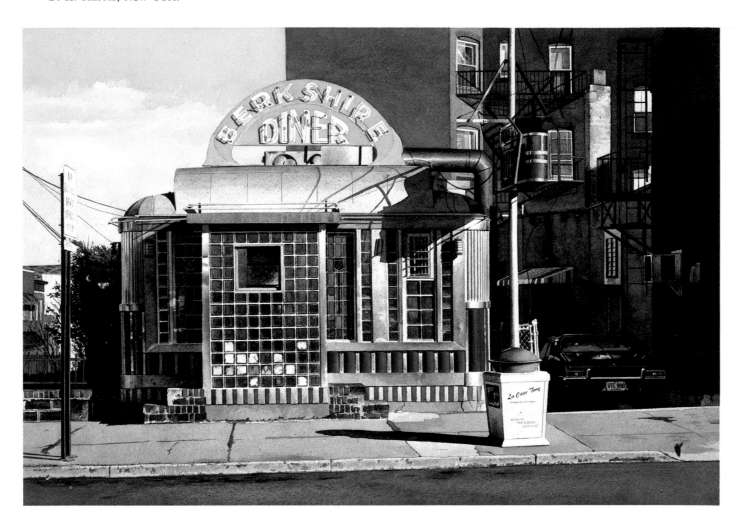

11 Robert Cottingham

Café Bar, 1980
Acrylic, 15⅛x23⅜ inches

12 Joseph Raffael

Orchids in July, 1979
Watercolor with rainwater, 45½x53½ inches
Nancy Hoffman Gallery, New York

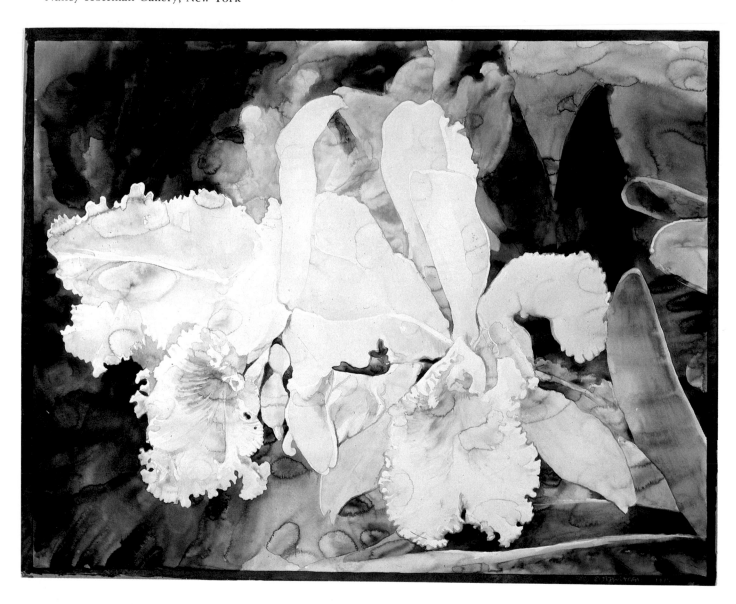

John Button
Lake Wesserunset: Approaching Sunset, 1978
Gouache, 25¾x19¾ inches
Fischbach Gallery, New York

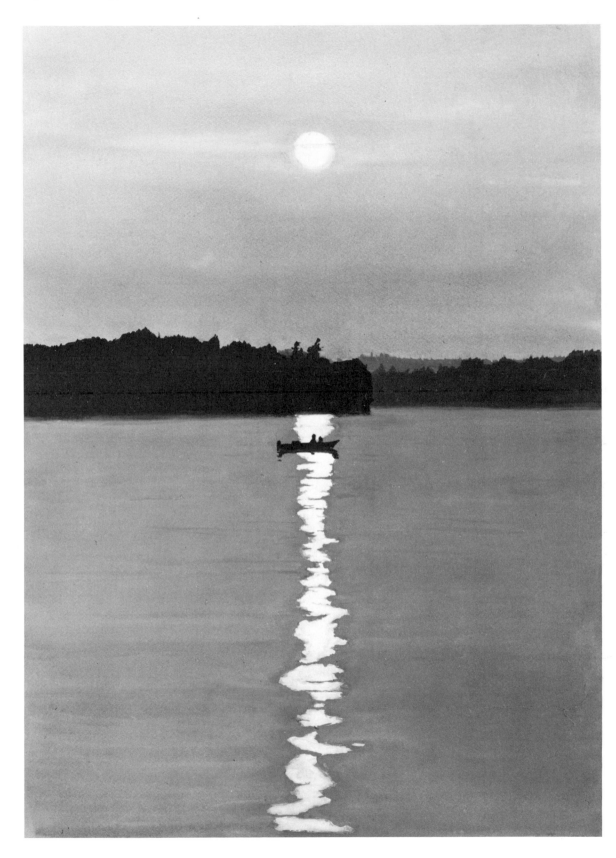

Jane Freilicher
Flowers I (Red Poppies), 1978
Pastel, 41½x29½ inches
Collection Dr. and Mrs. Arnold Cooper

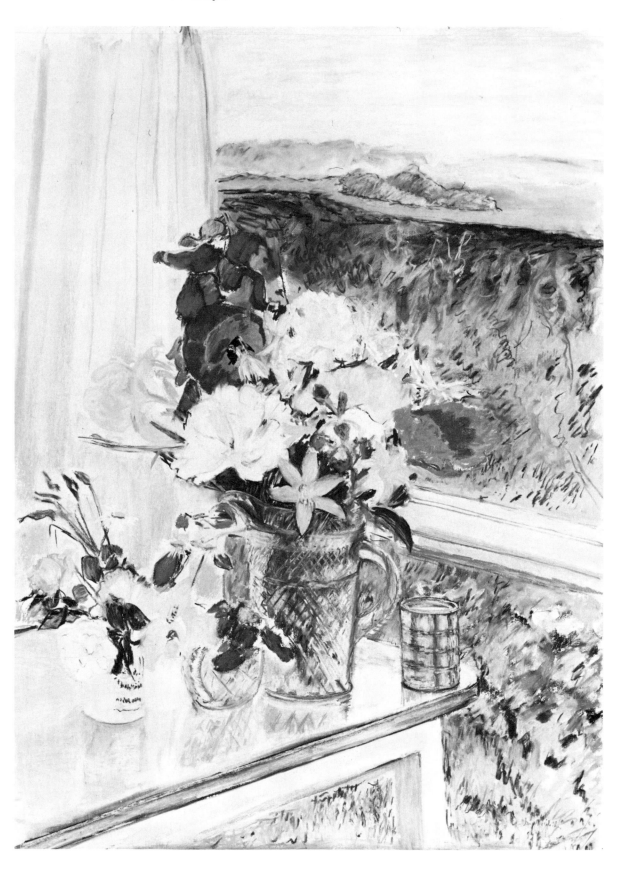

Jane Freilicher
Study for Autumnal Landscape 1978
Pastel, 29½x24 inches
Fischbach Gallery, New York

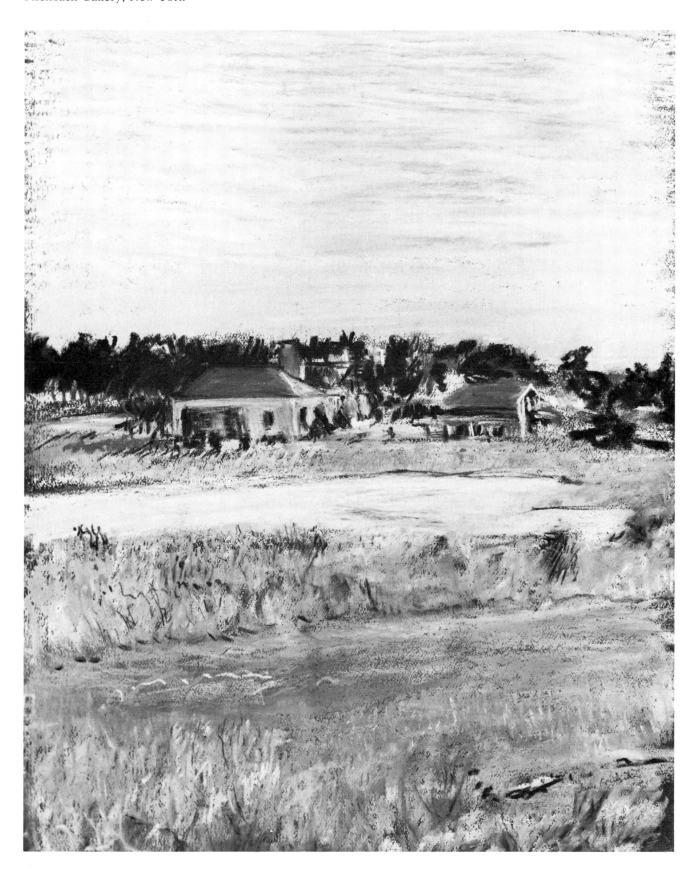

Neil Welliver
Briggs Meadow, 1977
Watercolor, 29⅝x30¼ inches
Brooke Alexander, Inc., New York

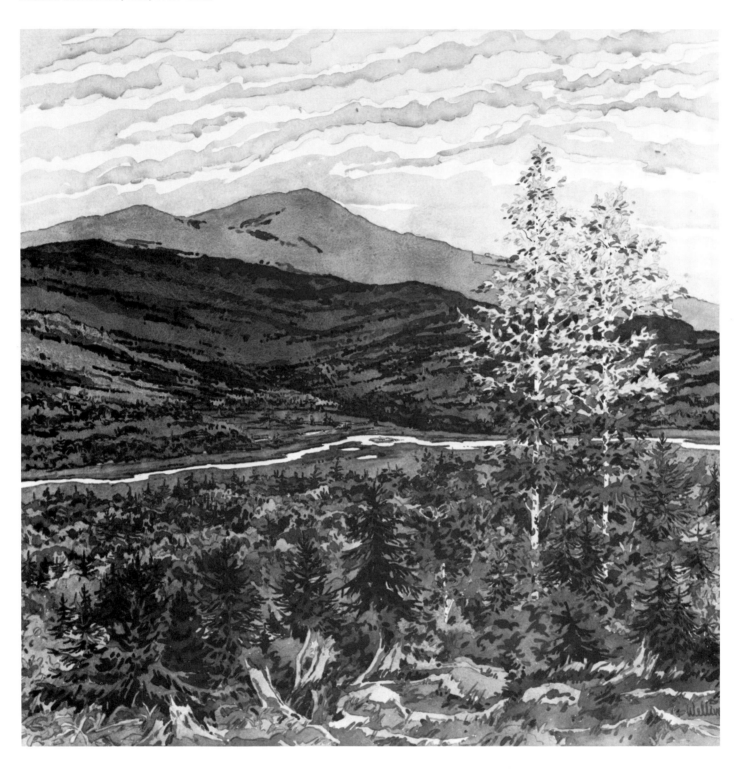

Neil Welliver
Immature Great Blue Heron, 1977
Watercolor, 24x22 inches
Brooke Alexander, Inc., New York

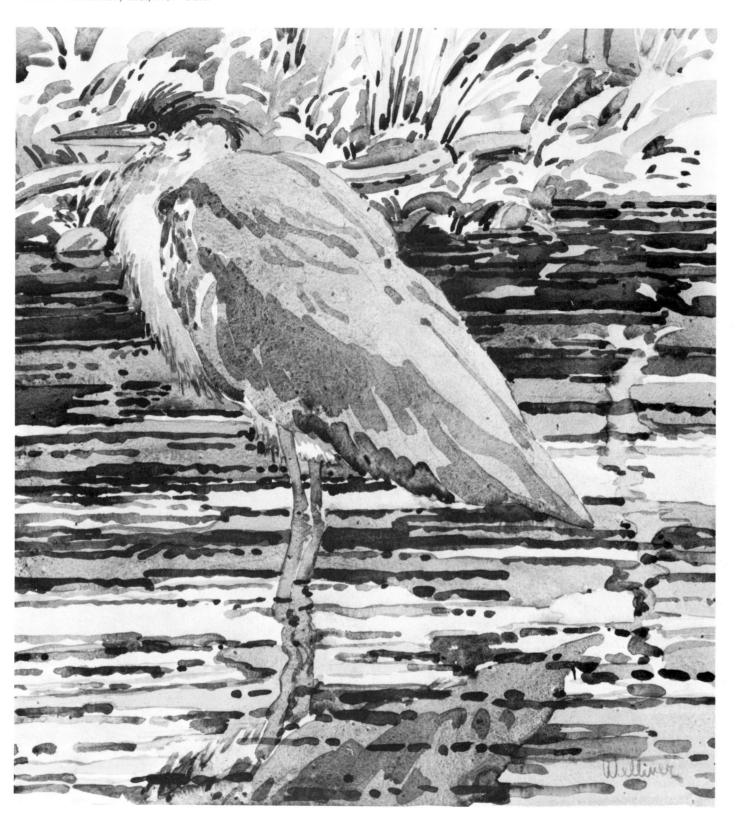

49

Richard Estes
Façade (Boston 5 with Stella), 1974
Gouache, 16½x17 inches
Allan Stone Gallery, New York

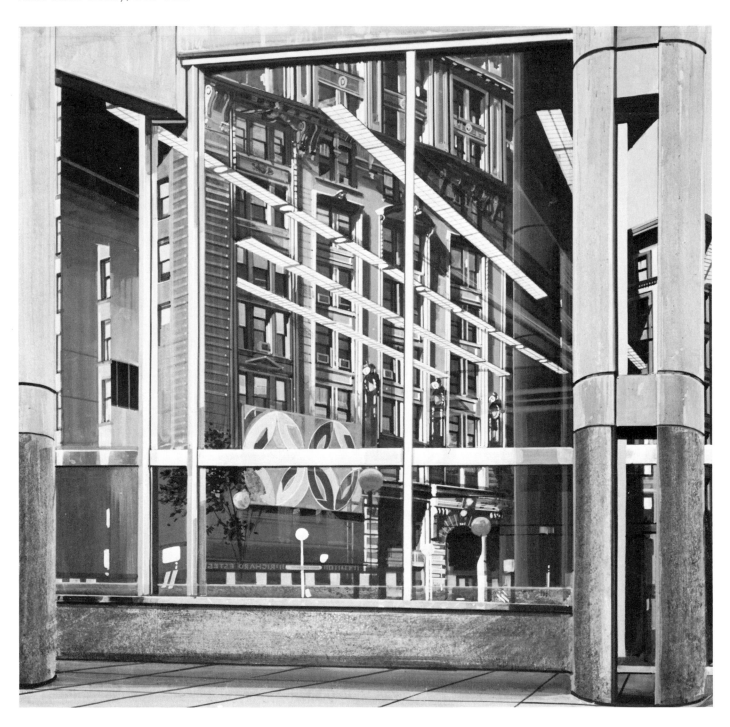

III

Photo-Realism

You shall stand by my side and look into the mirror with me.
Walt Whitman[1]

Photography, from its beginnings in pinhole projection, the camera obscura, and the light-sensitive copper plate invented by Daguerre in 1839, is tightly interwoven with the history of painting. Almost every painter has used systems and devices for reproducing the spatial world on a flat surface and for measuring and maintaining proportions. Daguerre simultaneously provided the painter with a permanent and convenient image and created another art form: photography.

The influence of photography on the painter lay in two areas: aesthetic, in the optical peculiarities of the photograph; and technical, in the availability of specific information, easily obtained. What were limitations and flaws in the process for the photographer were grist for the painter's mill: distortion, movement, random cropping, and exaggerated perspective. The feathery blur of leaves in late Corots, for example, suggest the moving subject in a long exposure, and the cropping of many of Degas's compositions owes as much to the snapshot as to the Japanese print. The painters were influenced by the look of photography, while many of the early photographers imitated the look and subject matter of painting. But in the twentieth century the two art forms tended to go separate ways, and it was only in the 1960s that the relationship was again frankly acknowledged with the advent of Photo-Realism.

The influence of Pop art on Photo-Realism has been overemphasized. Obviously, the banality of the subject matter of Pop, gleaned from the glut of images that bombard us, rendered with a sterile, mechanical, and deadpan look, had an effect. But the primary importance of Pop art is that it opened the door of the critical establishment to the emerging image and gave us subjects based specifically on our time and culture.

We must remember that the big shock of the Impressionists was what they chose to paint, coupled with the way they painted it. The titillating effect of much Photo-Realism is the choice of subject matter and the fact that the work doesn't look painted. In the end its merit, like that of the best art of all forms, must rest on its resonance, not on a "hard-to-do" look and coy imagery.

To discuss Photo-Realism, one must focus on Richard Estes. Although there were precedents in the work of such artists as Malcolm Morley, Lowell Nesbitt, and Howard Kanawitz, it is Estes, from his first exhibit in 1968, whose paintings have thoroughly influenced the look, the choice of subject matter, and the air of objectivity that permeate Photo-Realism.

The precedents in painting for Estes's urban images are easy to identify: Canaletto and Guardi, and more recently, Hopper and Sheeler. But little has been said about the precedents in photography, which are equally

Richard Estes
Hotel Paramount, 1974
Gouache, 14¼x19½ inches
Allan Stone Gallery, New York

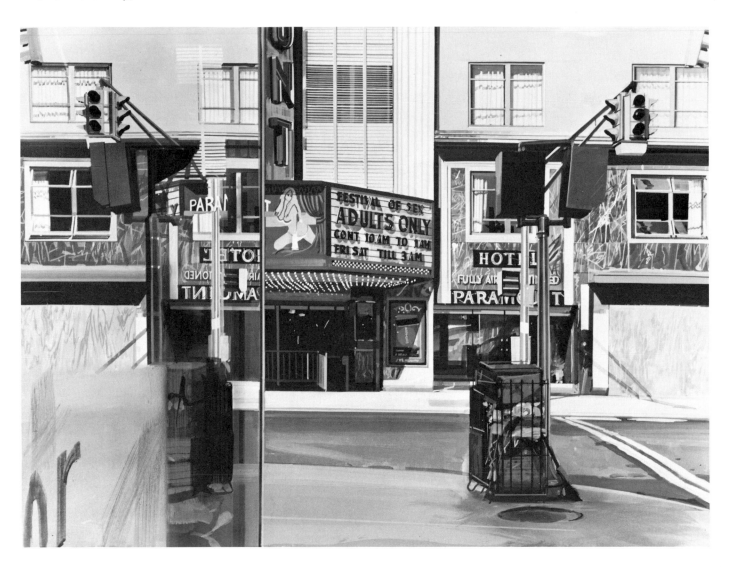

important. Whether it is a case of influence, common aesthetic ground, or parallel sensibilities, Estes has more in common with Atget and Walker Evans than with the painters most often cited, with the exception of Hopper. One need only look at images like Atget's *Doll Shop* or Walker Evans's *License-Photo Studio, New York* or Berenice Abbott's photographs of New York.

The tidal wave of Photo-Realism in the early seventies was to some extent the results of a misreading by other artists of Estes's paintings, which were seen in small reproductions that made them look like photographs rather than paintings. Ironically, his influence was enormous, but his procedure and intent were distorted by photo-reproduction. Richard Estes is a "painterly" artist, and he is the most intuitive of the contemporary Realist and Photo-Realist painters. His paintings are reconstructed from photographs rather than literally copied from them, and they are keenly edited, which accounts for their clarity and crispness.

This simplification and editing of data gleaned from photographs can be readily seen in the gouaches (which are often a combination of acrylic,

oil, designers' colors, and so forth); in *Bridge* (Plate 7), in details such as the columns on the bridge, chain in the foreground, the water, and the flat-colored building in the background; in *Façade* (*Boston 5 with Stella*), in the reduction to three or four tones of the reflected façade. The economy of means can be seen in almost every detail of *Hotel Paramount* of the same period. His process becomes clearer if one thinks of these small pieces as a parallel to what one would see in a detail of a large painting, as opposed to a large painting reduced to this size, with the resultant visual confusion.

Estes's only drawings, in the traditional sense of the term, are underneath the paintings. He does not regard them, or his monochromatic works, as being finished.

The works of the great documentary photographers of the twenties and thirties, paralleling the paintings of many of the Photo-Realists in subject, viewpoint, and perception, were regarded primarily as reportorial and journalistic, but with the passage of several decades journalism became historical document, and then historical document became art — or rather, the aesthetic values came to be considered of dominant importance. In time, the response to Photo-Realism may follow a reverse path, with growing value given to these works as a record of a milieu through the edited and selective vision of the artist.

In 1969 Ralph Goings was producing snapshot-like paintings of pickup trucks parked on small-town streets. These works had an artless and informal quality and were painted with an almost invisible hand. With his move from the West Coast to a rural location in New York state in the mid-seventies, his subject matter shifted to the architecture of the drive-ins and fast-food chains — those archetypal structures with instantly recognizable design promising all who pass a consistent, if bland, experience. Permission for the use of such banal imagery had been gained by the Pop artists.

Goings's work blossomed as he moved into the interior. He placed more emphasis on the play of light on the shiny, synthetic surfaces and on the definition of space carved by light and shade. Coupled with these works are beautiful still-life oils and watercolors. Too richly observed, tender, and comfortable for the irony of Pop or hard-line Photo-Realism, these pieces connect with the traditional genre paintings and still lifes (Plate 8).

Ralph Goings begins his oils and watercolors with a delicate pencil tracing made from a slide projected on the canvas or paper. Some compensations and corrections are made for lens distortions, but focus is retained. The background is painted first, and then he proceeds from object to object. Trademarks, mass-produced objects, and packaging abound, and they are tenaciously rendered. But in the recent work there is a resonance and sympathy toward the subject that was not clear before.

At a glance, Robert Bechtle's paintings seem to be stylistically quite similar to Goings's, but close examination reveals subtle simplifications of the forms not present in Goings's work, less emphasis on the reflective surfaces, and more sculptural modeling of the figures and faces. Those characteristics are carried into the watercolors and drawings, which also are begun from projected slides (Plate 9). While Goings does watercolors but no drawings, Bechtle does both, although the drawings are fewer. His monochro-

Ralph Goings
General Store Ford, 1975
Watercolor, 10½x15 inches
Collection Ivan and Marilyn Karp

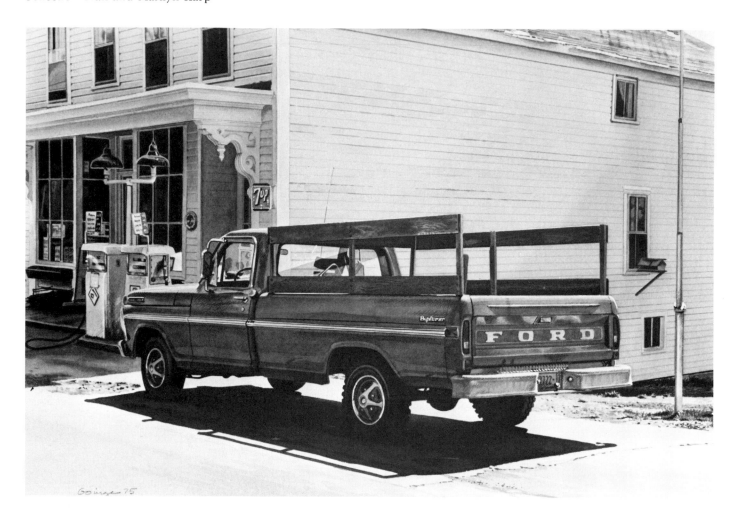

matic pieces, such as *Warm Springs Patio,* are done with conté crayon or charcoal, and are constructed tonally, with a total absence of line, like Seurat's marvelous drawings. They are very crisp and sparkling examples of chiaroscuro drawing.

Bechtle's recent work continues to depict symbols of status and comfortable living, but the spaces have deepened and have become more populated. The inhabitants pause in their somewhat banal activities to gaze self-consciously toward the recording camera. With their commonplace themes these paintings suggest something of Dutch genre paintings or the images in a family album.

> I closely identify with the photographers who worked for the Farm Security Administration. Perhaps that's why so many of my paintings have a "documentary" look rather than a "painterly" look (here again the ever-present fascination with the street photographer).
>
> John Baeder[2]

In the early seventies, Baeder produced a series of monochromatic paintings from photographs and postcards. Some were made from FSA photographs

Robert Bechtle
Warm Springs Patio, 1979
Charcoal, 12x18 inches
Collection of the artist

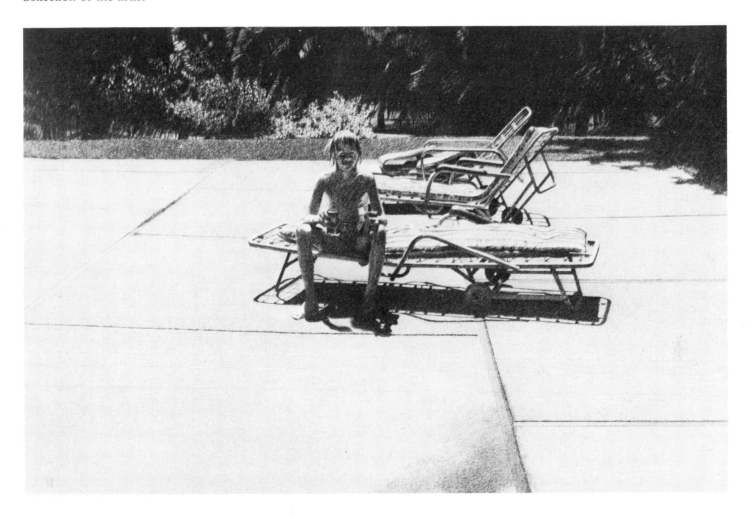

made in the thirties by Russell Lee, which Baeder purchased from the Library of Congress.

Baeder loves diners as a social phenomenon, as vernacular architecture, for their ambiance, their nostalgia — and their cooking. He seeks out and records them with the enthusiasm of a child collecting bubble-gum cards. He portrays them in oil, watercolor, etchings, and lithographs; whole in their urban context, or as façades, or in details — signs, clocks, counters, grills, napkin holders, ashtrays, sugar jars, and stainless steel fluting. Interest has blossomed into obsession. He is an urban archaeologist recording the specifics and essence of a disappearing, endangered feature of our culture, in its dual aspect as an urban service and as a form of folk art (Plate 10).

It is common to denigrate commercial art and graphic design, but it is a functional art form that requires formal skills and precision combined with speedy execution. Thiebaud, Pearlstein, Baeder, and Estes made their livings as commercial artists at early stages of their careers and found the experience beneficial to them as painters. Robert Cottingham broke off a highly successful career in advertising to devote himself to painting, particularly the metal and neon signs indigenous to our urban culture. These

55

John Baeder
Wally's Diner, 1977
Watercolor, 22x24½ inches
O. K. Harris, New York

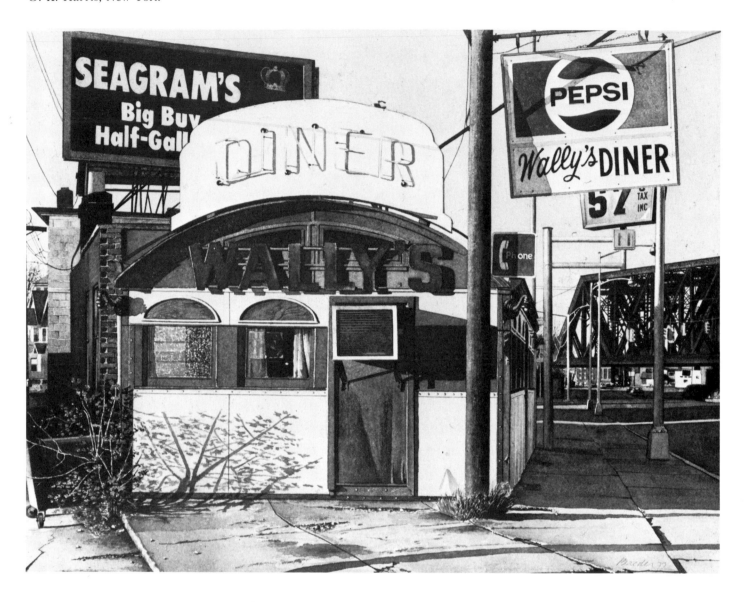

Robert Cottingham
Ideal Cleaners, 1979
Pencil on vellum, 15½x15½ inches
Collection of the artist

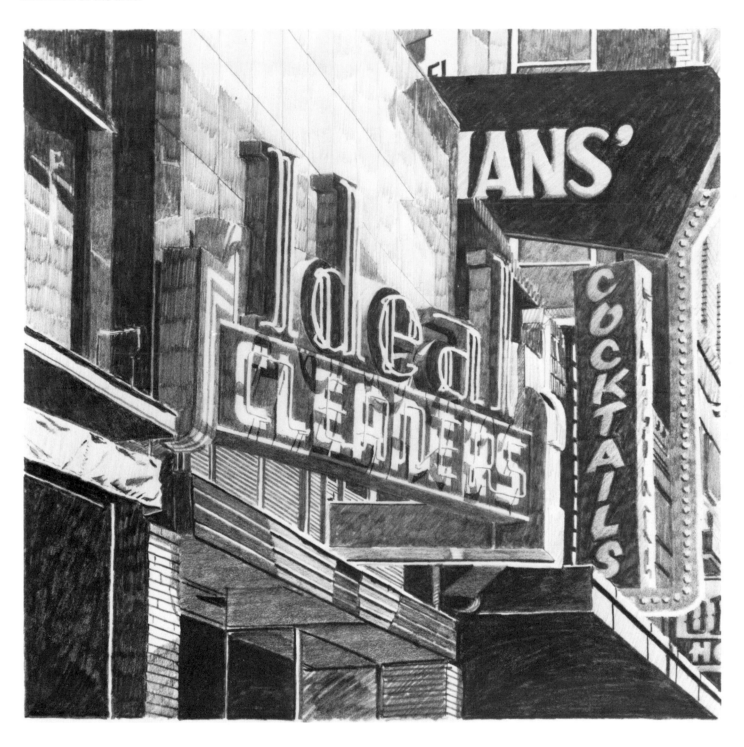

Robert Cottingham
Liquor
Pencil on vellum, 17x11¼ inches
Collection of the artist

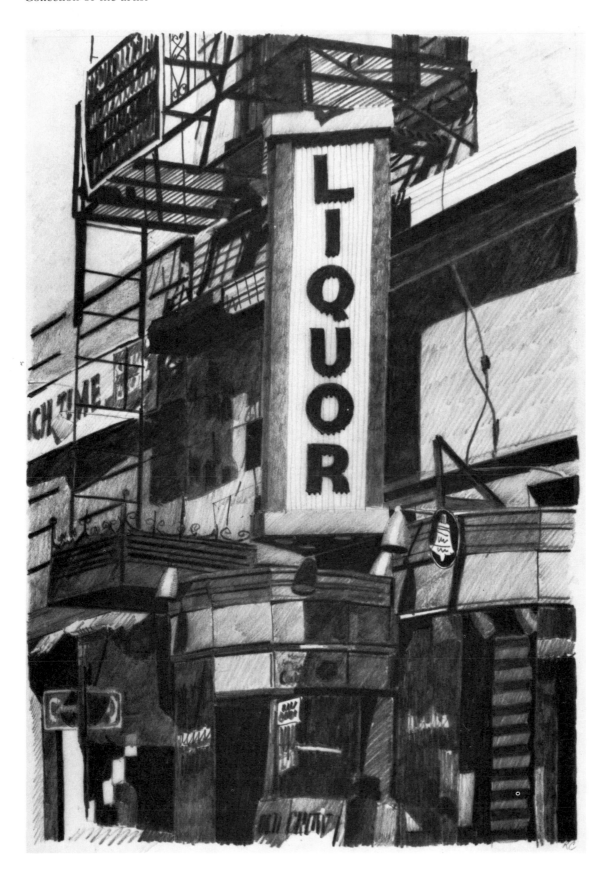

Lowell Nesbitt
Hollywood House, 1971
Pencil, 30¼x40 inches
Collection of the artist

constructions we pass under daily are intended to inform and induce. They compete above our heads in a cacophony of abstract polychrome shapes replete with letters, names, slogans, and emblems. In his paintings, drawings, and prints, which are begun with projected slides, Cottingham depicts these advertising structures as seen from the sidewalk. The images are judiciously composed and edited, and at times the cropping adds, by the elimination of some of the letters, visual puns. Unlike other Photo-Realists, Cottingham does not emphasize the tactile qualities, and the protruding forms and patterns are enhanced by shadows and subtle departures from local color.

In reproduction, it is impossible to distinguish between a large painting and a small acrylic on paper, like *Café Bar* (Plate 11), for there is no clear clue in the handling to the reduced scale. The small acrylics look as if they had been done with airbrush; there is no sign of brushwork, for Cottingham successfully works wet into wet with this fast-drying medium.

59

James Valerio
Still Life with Tomatoes #1, 1979
Pencil, 48¼x85¼ inches
Frumkin & Struve, Chicago

His pencil drawings, like *Liquor* and *Ideal Cleaners*, are rich tonal constructions and offer full evidence of his hand with their rapid, crosshatched construction. They are reminiscent of the thumbnail sketches frequently employed by illustrators.

Cottingham, like Thiebaud, Chuck Close, and Katz, recycles his images. Large paintings, acrylics on paper, drawings, and prints are often made of the same composition.

One of the earliest Photo-Realists, but one who has always had more painterly inclinations, Lowell Nesbitt is a compulsive and highly prolific worker. The volume of his paintings, prints, and drawings far surpasses that of any other contemporary Realist. He works from photographs he has taken himself or has directed a photographer in taking, and with the help of assistants he works on many pieces in an orderly rotation. He is best known for his large paintings of flowers, but they are only the tip of the iceberg of his repertoire of images, which includes landscape, still lifes, his large wardrobe, interiors, figures, and portraits of his dog Echo.

Large black-and-white drawings, like *Hollywood House,* while offering little indication of his range of images, illustrate Nesbitt's method of simplifying and dramatizing from the photographic source material, and they retain the evidence of his hand.

James Valerio, one of the most meticulous and ambitious of the Photo-Realists, produces about four large paintings a year. These impressive showpieces, which are painted with the sparkling clarity, clean color, and

60

James Valerio
Female Model on Sofa, 1979
Charcoal, 30¼x42¼ inches
Allan Frumkin Gallery, New York

lucid detail of a Dutch still life, usually depict narrative, but somewhat inexplicable, events. While the rendering of the surfaces and the jewel-like color are extremely seductive, the situations and subjects described and the meticulous delineations of physical details are disconcerting to most viewers. We are attracted by the artist's skill when it is mobilized for accurate description of the beautiful surfaces of a flower or sliced cabbage, and repelled by such accuracy when it is employed to reproduce the knotty muscles of a woman's knee.

This aspect of his work, and the lack of meaningful representation in the East, tended to minimize Valerio's recognition. The situation changed drastically, however, with the major opus he produced at Allan Frumkin's request for *The Big Still Life* exhibition at the Frumkin Gallery in 1978. Although the large museum exhibitions are important, it should be noted that the gallery shows play a highly significant role in that they inform and influence the working artists and can have a rippling impact on the artists themselves.

61

Joseph Raffael
Hyacinth, 1975
Ink and ink wash, 22½x30 inches
Nancy Hoffman Gallery, New York

Valerio and Goings accurately describe tactile surfaces; Joseph Raffael, like Thiebaud and Welliver, creates visual parallels to the tactile qualities of his subject through the natural propensities of the medium. Raffael, like Estes, is extremely popular with the public. Both have immense and readily recognized skills and both produce beautiful pictures, but whereas Estes renders man-made environments, with all their faults, Raffael gives us a primeval and untroubled view of nature, apparently untouched by man. It is nature altered by the elements: water, wood, stone, and flower can be taken as such, but there is also a poetic and mystical layer.

Raffael used photographic source material gleaned from periodicals in his early work, and also in a series in which he moved closer to his creative center, paintings based on slides of streams by his friend William Allan. These "water paintings," done in 1972 and 1973, are rendered with trans-

Joseph Raffael
Fish in Spring Water, 1979
Watercolor, 42½x32¼ inches
Nancy Hoffman Gallery, New York

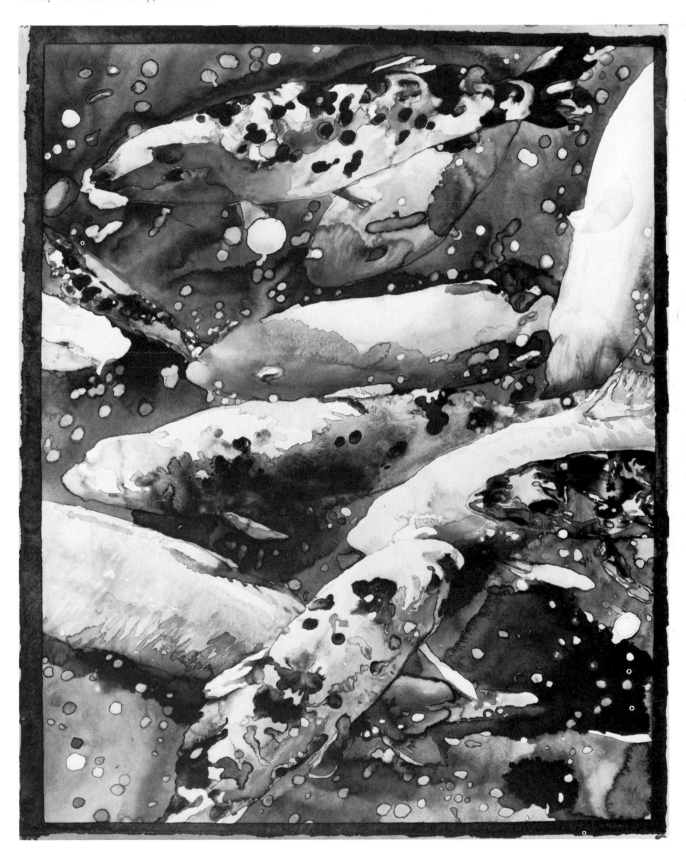

parent oil on a nonabsorbent surface. The rich, clean color sits in rings and ovals that describe the beads of light encountered through a lens rather than the forms.

Exact creative center was reached when the artist began taking his own photographs. Oils, watercolors, and occasional drawings, like *Hyacinth,* are made from slides and color prints, but unlike Goings and Bechtle, who also project slides, Raffael traces the contours of the patterns of light and colors rather than the form of the object.

Works like *Orchids in July* (Plate 12) are very large for watercolors, and the flowers and foliage are greatly magnified — currently a frequent practice, one that was initiated by Georgia O'Keeffe. In contrast to Raffael's oils, where the transparent paint slips and reticulates on the gessoed surface and the white sizing of the canvas is incorporated for the lights (a watercolor technique), here the watercolor soaks into the paper in wet stains. It is a strong and natural use of the medium. As in the oils, the resulting image is a reflection of the light rather than a description of form. The watercolors evoke a pleasurable, sensual response to veils and rivers of color, the kind of response aroused by the paintings of Morris Louis and Helen Frankenthaler.

> There were lots of rules, too, in art school. Like, heads couldn't be bigger than life size — rules from classical sculpture. People were not supposed to be able to relate to bigger than life-size sculpture, but at the same time we were all looking at billboards, Cinerama, etc. . . .
>
> I don't want to pose the sitter or alter the image in any way that will amplify or orchestrate for effect or lobby for humanism. . . .
>
> I wanted to define the image by the surface activity, not by the symbol.
>
> Chuck Close[3]

It is important to take Chuck Close at his word. His large, dispassionate, airbrushed images of the human head, images as artless as passport photos, are not portraits in the traditional sense and seem only tangentially to be about painting. They are based on photographs of family and friends from the art world he has taken with a studio camera, but one cannot tell if the subject is a stockbroker, a painter, a poet, or one of the "ten most wanted." These mug shots give us highly detailed and specific information about physical facts, but we can glean nothing in regard to personality. Close operates at the opposite pole from Beal, Katz, or Alice Neel.

In these mammoth faces, as devoid as possible of the individual presence, the artist works like a cartographer, concentrating on the reception, codification, transformation, and comprehension of visual information. This codification of information is more easily understood through the drawings, of which Close has said:

> In the dot pieces [the "drawings"] I grid off a photo and I grid off the paper. I generalize about each grid on the photo — on the drawing I mentally divide each dot into four parts and try to fill in the parts in a general way; that is,

Chuck Close
Phil/Fingerprint: Random, 1979
Stamp-pad ink, 40x26 inches
The Pace Gallery, New York

Chuck Close
Robert/Square Fingerprint II, 1979
Pencil and stamp-pad ink, 29½x22½ inches
The Pace Gallery, New York

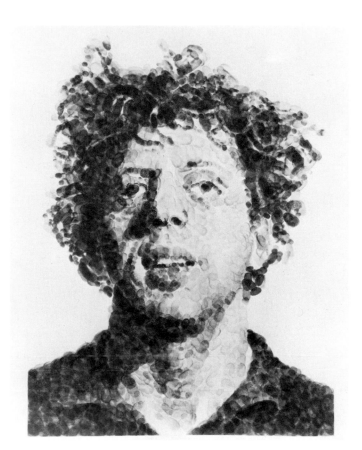

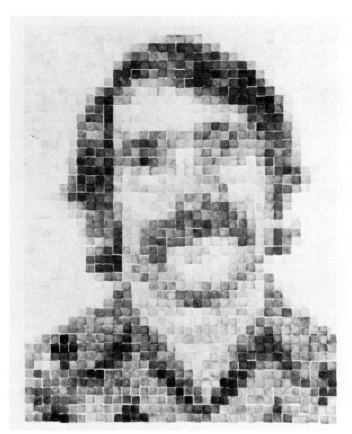

within the limitations and with only a few possible choices, I reproduce that small area freely and intuitively.

I don't do preliminary drawings for paintings. I usually do drawings *after* the painting, that is, I recycle the image.[4]

In Close's ink and graphite drawing, *Don N.* (Don Nice), the tonal value of each square in the grid is summarized, and because the grid is small much specificity is retained; in *Robert/Square Fingerprint II,* however, the grid is larger, forcing a broader generalization of the tonal information. One knows that it is a head, but the specific information has been greatly reduced.

Phil/Fingerprint: Random contains more information (it is larger), and because the rigidity of the grid is avoided through the random placement of the tonal ovals, it takes on an impressionistic quality. Ironically, and perhaps tongue-in-cheek, through the use of fingerprints and inkpad it becomes a "signature" piece.

Ben Schonzeit is best known for his large, highly informed, airbrushed transcriptions of photographs, painted on top of the projected images in a darkened studio. He has now moved away from high-gloss, hard-core Photo-Realism with a series of paintings, drawings, and collages based on a single photographic image of a music room at the Metropolitan Museum.

Chuck Close
Don N., 1975
Ink and graphite, 30x22 inches
The Pace Gallery, New York

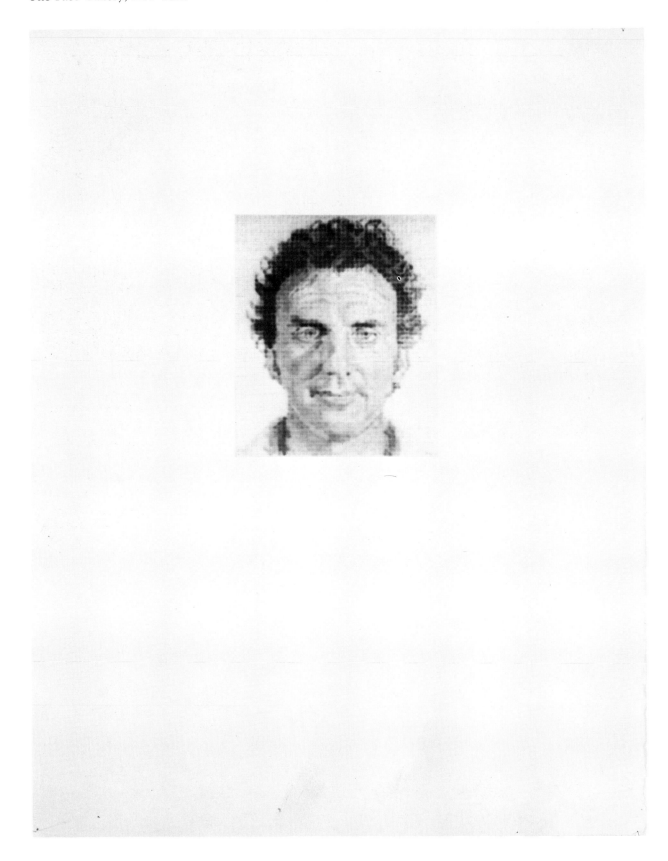

Ben Schonzeit
The Music Room #7, 1977
Watercolor, 30x30 inches
Nancy Hoffman Gallery, New York

Ben Schonzeit
The Music Room #13, 1978
Pastel on acrylic, 30x30 inches
Nancy Hoffman Gallery, New York

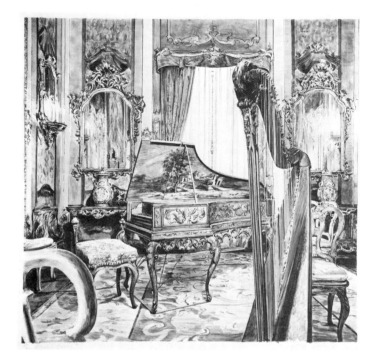

Each piece is in a different medium and takes a different expressive stance in interpreting this single recycled image.

These variations on *The Music Room* met with hostility from some critics, but it was a courageous move by this virtuoso artist and can be seen symbolically as the end to the highly skilled duplication of photographic source material, transposed but not stamped by personal sensibility and vision. These works of Schonzeit complete the cycle, moving from the use of subject matter as a means of displaying virtuosity to the return of the subject as a vehicle for content and/or ideas.

1. Walt Whitman, preface to 1855 edition of *Leaves of Grass* (New York: Doubleday, Doran & Co., Inc., 1940).

2. John Baeder, *Diners* (New York: Harry N. Abrams, Inc., 1978), p. 108.

3. *Allan Frumkin Gallery Newsletter,* no. 7 (Winter 1979): 2.

4. *Ibid.,* p. 5.

James McGarrell
Native Inventions on Bad Elipses — Temporale, 1976
Pencil, 6¾x9¾ inches
Allan Frumkin Gallery, New York

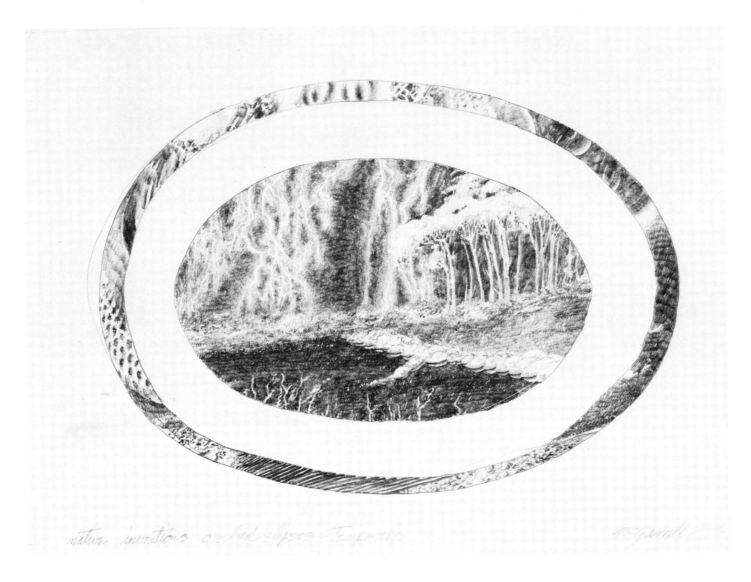

IV

Realism:
Variation and Divergence

Our view of reality is conditioned by our position in space and time — not by our personalities as we would like to think. Thus every interpretation of reality is based upon a unique position. Two paces east or west and the position is changed.

Lawrence Durrell, *Balthazar*[1]

It is interesting to speculate on Rembrandt's choice of subject matter had he lived in the twentieth century; the paintings Van Gogh might have produced had he, instead of Gauguin, sailed to Tahiti; how Frederick Church's sublime landscapes might have looked had he read *On the Origin of Species* or encountered our ecological disasters; what Rubens might have done as a movie director. Such conjecture can go on infinitely, for each artist is shaped by his time and geography, and to shift the sequence or locales would alter his work drastically.

Although the contemporary Realists share (roughly) a moment in time, the differences in their space — both personal and geographical — shape different works. To place all figurative art under the mantle of Realism without distinction is a disservice to the artists and a hindrance in unraveling the diversity of their intentions. Anyone who visits the art galleries with regularity is aware of the wide range of possibilities for expression in recent art. As Robert Hughes observed:

> The American mainstream has fanned out into a delta, in which the traditional idea of the avant-garde has drowned. Thus in defiance of the dogma that realist painting was killed by abstract art and photography, realism has come back in as many forms as there are painters.[2]

With this in mind, we will briefly explore the diverse forms and turns in recent figurative art.

Elmer Bischoff and James Weeks, like Richard Diebenkorn, are Bay Area figurative painters (although Weeks moved to Massachusetts ten years ago). Bischoff has turned from figurative to abstract painting, as has Diebenkorn, while Weeks has maintained a figurative stance with a Bay Area accent.

Bischoff's drawings explore the facts of the studio, the ageless theme of artist and model, and like Diebenkorn's drawings are marvelously fluid chiaroscuro constructions in a combination of media such as charcoal, chalk, and gouache. Occasionally figures are cut from other drawings and added, such as the foreground figure in *Two Models, Large Room*.

Compared with Diebenkorn and Bischoff, James Weeks is more inclined toward the specificity of the individuals in his drawings. They are

crisp summations of appearance and attitude. The portrait of the poet Lawrence Ferlinghetti, drawn with a fluid charcoal line and sparingly modeled with a tonal wash, has — like certain Matisse charcoal drawings — the sculptural quality of a low relief. In *Musicians,* the graceful line, varied with pressure on a gessoed paper and delicately toned with pale stains of wash, illustrates Weeks's highly refined and economical skills as a mature draftsman.

By comparison, the drawings of Michael Mazur and Sidney Goodman are inclined more to narrative. Both use a dry medium: Mazur pastel and Goodman charcoal. Mazur's *Dancer I* alludes to the visual perception of movement and focus via photography's impact on painting (as in the studies of Eadweard Muybridge and Duchamp's *Nude Descending a Staircase*).

Goodman's figures are beautifully drawn, with baroque lights and darks; in the example here a model reclines on top of a table. An emotional tension arises from the veiled, undefined psychological state.

A more explicit mood is conveyed in the expressionistic portrait drawings of Red Grooms, Alice Neel, and Luis Cruz Azaceta. The heavy *angst* of their northern European predecessors is gone, dissipated by the artists' great rapport with their subjects; their drawings are at times laced with humor and even incline toward caricature.

Red Grooms, while best known for his sprawling monumental mixed media sculptures, such as *Ruckus Manhattan,* is more than a "closet" painter and a formidable draftsman. The marvelous *Max Jacob,* drawn from an old photograph, demonstrates Grooms's witty and insightful rummaging through art history. His humor and charm conceal the sharp intelligence behind his work. The watercolor *Self-Portrait* (Plate 13), quite simply one of the finest contemporary drawings, is a strong reminder of his abilities as a painter.

Alice Neel chooses her portrait subjects and then proceeds to dissect them while filling their ears with banter. Her combination of curiosity and honesty, illustrated here in the drawing *Adrienne Rich*, is often mistaken for cruelty.

Luis Cruz Azaceta is a Cuban refugee, and his pictures are loaded with references to his ethnic background. These expressionistic portraits have two layers: in the *Self-Portrait with Red Rose,* he poses in front of the mirror studying his countenance, acting out stances that allude to cultural stereotypes — the Latino brandishing a knife, decked out in a funky hat or flashy shirt, lips curled between a smile and a snarl. Azaceta stares into his mirror, records his likeness in brightly colored washes of magentas, blues, greens, and oranges, and his image stares back at us with humor and menace.

Grooms, Neel, and Azaceta illustrate the possibilities of an uncanny (if somewhat unflattering) summation of character through an expressionistic approach. Their portraits stand as testimony to Matisse's dictum, "Exactitude is not truth." So, in a negative sense, do the portraits of Chuck Close, but from the opposite pole, for he has amply demonstrated that an accurate and highly descriptive account of one individual's physical state can remain devoid of personality.

Elmer Bischoff
Two Models, Large Room, 1961
Charcoal, gouache, collage, 17½x23 inches
Collection of the artist

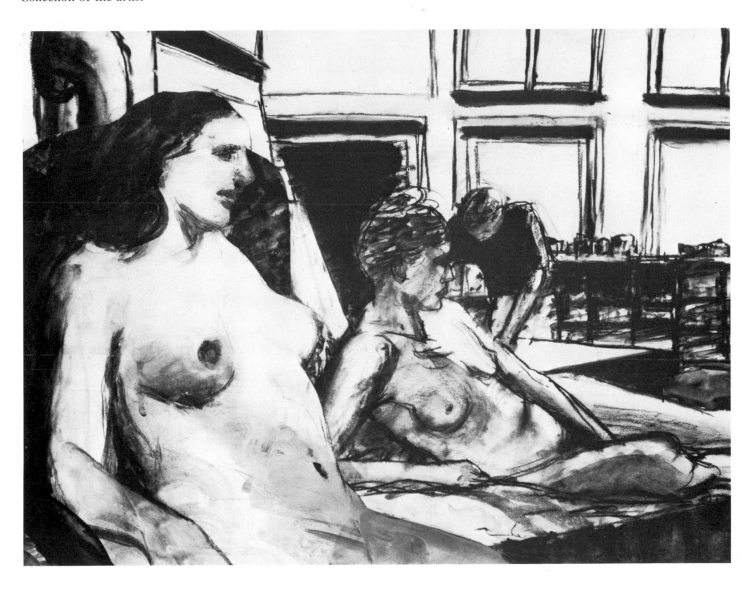

With Close representing one extreme and Grooms, Neel, and Azaceta the other, a middle ground — accuracy of appearance and a more naturalistic assessment of the individual — is reflected in the drawings of David Hockney and the late Willard Midgette.

David Hockney, an immensely popular British artist, spends much of his time in the United States. He has seen more of this country than most Americans have, and the paintings and drawings he has produced of Los Angeles are perhaps the most accurate images we have of the ambiance, of the peculiar mood, look, and lifestyle of that special place.

Hockney draws beautifully, and draws a lot, often using the simplest and most economical means, pen and ink. With great charm and wit he describes his sitters in unerring line. The drawing of his mother reflects his affection for her and her pride in her son. It is accurate, tender, and respectful. Sir John Gielgud, the internationally acclaimed actor, is revealed

Elmer Bischoff
Two Models and Two Lamps, 1961
Charcoal, gouache, collage, 17½x23 inches
Collection of the artist

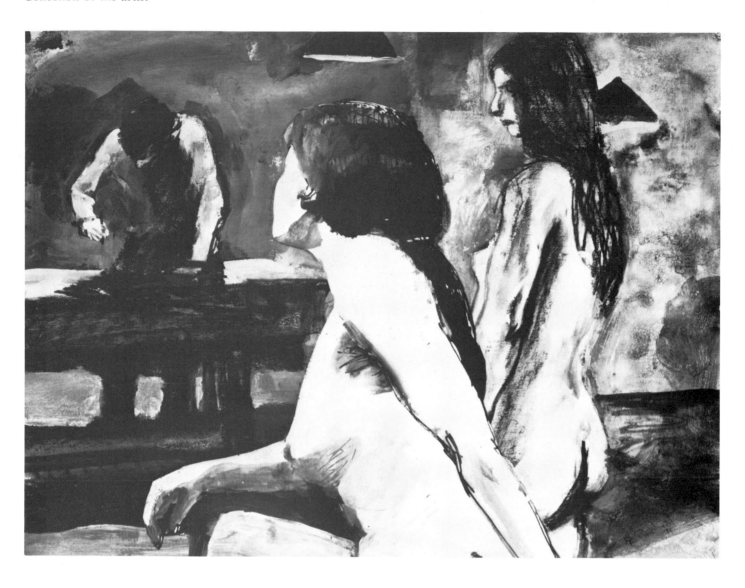

Michael Mazur
The Dancer I, 1979
Pastel, 49x35½ inches
Robert Miller Gallery, Inc., New York

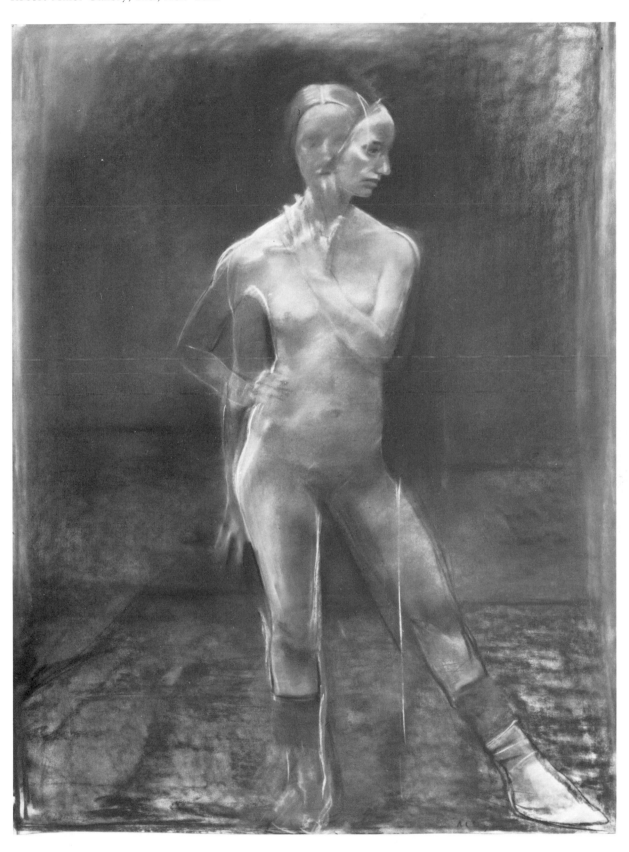

James Weeks
Portrait of Lawrence Ferlinghetti, 1961
Charcoal and wash, 20x23½ inches
Collection of the artist

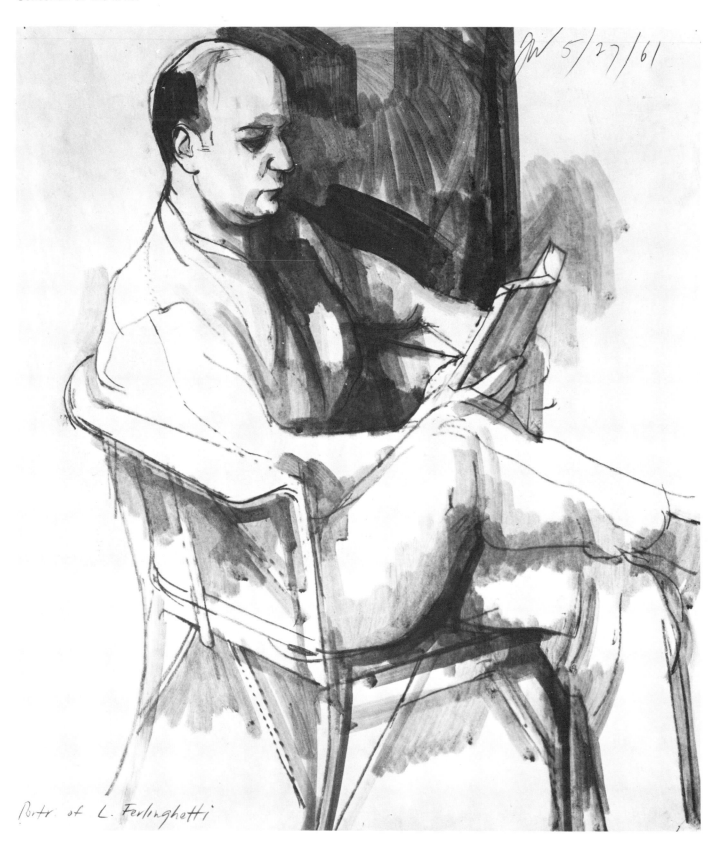

Portr. of L. Ferlinghetti

James Weeks
Musicians, 1972
Charcoal and wash on gessoed paper, 20x26 inches
Charles Campbell Gallery, San Francisco

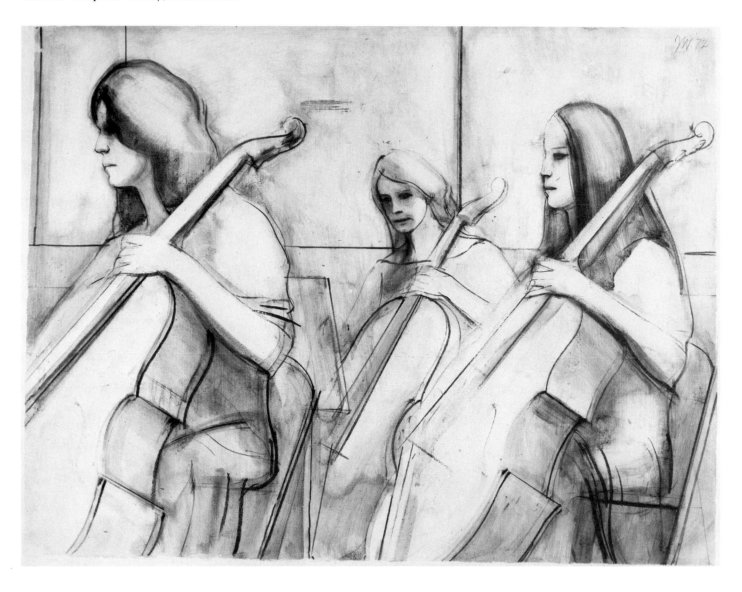

Sidney Goodman
Nude on Table, 1973–74
Charcoal, 29¾x41½ inches
Terry Dintenfass, Inc., New York

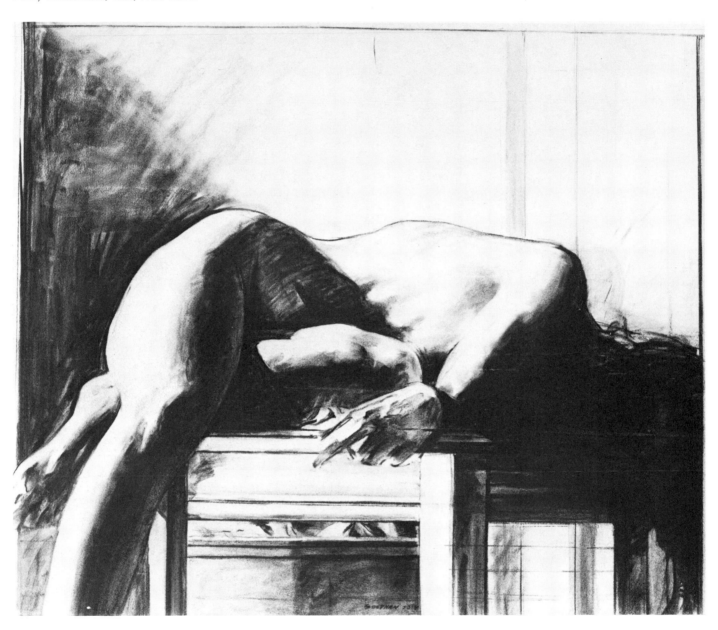

Red Grooms
Max Jacob, 1973
Ink, gouache, and pencil, 35½x22½ inches
Brooke Alexander, Inc., New York

Alice Neel
Adrienne Rich, 1973
Ink heightened with Chinese white, 30x22 inches
Graham Gallery, New York

Luis Cruz Azaceta
Self-Portrait with Red Rose, 1979
Colored inks and colored pencil, 38¼x25¼ inches
Allan Frumkin Gallery, New York

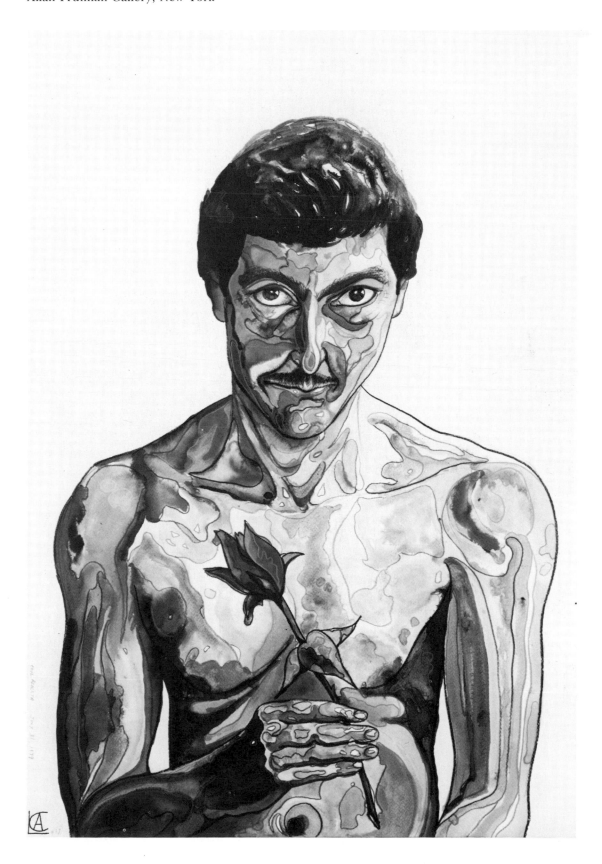

David Hockney
Mother in Check Dress, Wales, 1977
Ink, 17x14 inches
André Emmerich Gallery, New York

David Hockney
Sir John Gielgud, 1977
Ink, 17x14 inches
André Emmerich Gallery, New York

Willard Midgette
Study for Portrait of Sally, 1977
Pencil and charcoal, 35x25½ inches
Allan Frumkin Gallery, New York

Willard Midgette
Study for Portrait of Dameron and Anne, 1977
Pencil and charcoal, 26¼x23¼ inches
Allan Frumkin Gallery, New York

Catherine Murphy
Harry Roseman Working on Hoboken and Manhattan, 1978
Pencil, 13¾x11 inches
Xavier Fourcade, Inc., New York

Catherine Murphy
Still Life with Pillows and Sunlight, 1976
Pencil, 8⅝x12½ inches
Xavier Fourcade, Inc., New York

William Bailey
Saria, 1978
Charcoal, 30x22¼ inches
Collection J. and R. Davidson, Boston

William Bailey
Seated Woman, 1979
Pencil, 14¾x11 inches
Robert Schoelkopf Gallery, New York

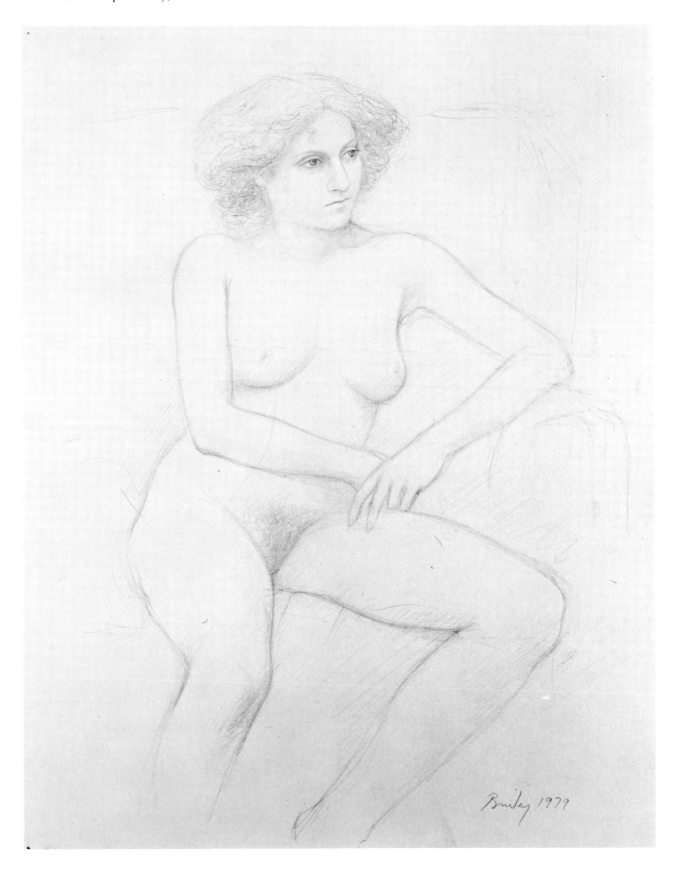

William Beckman
Diana IV, 1980
Pencil, 29x23 inches

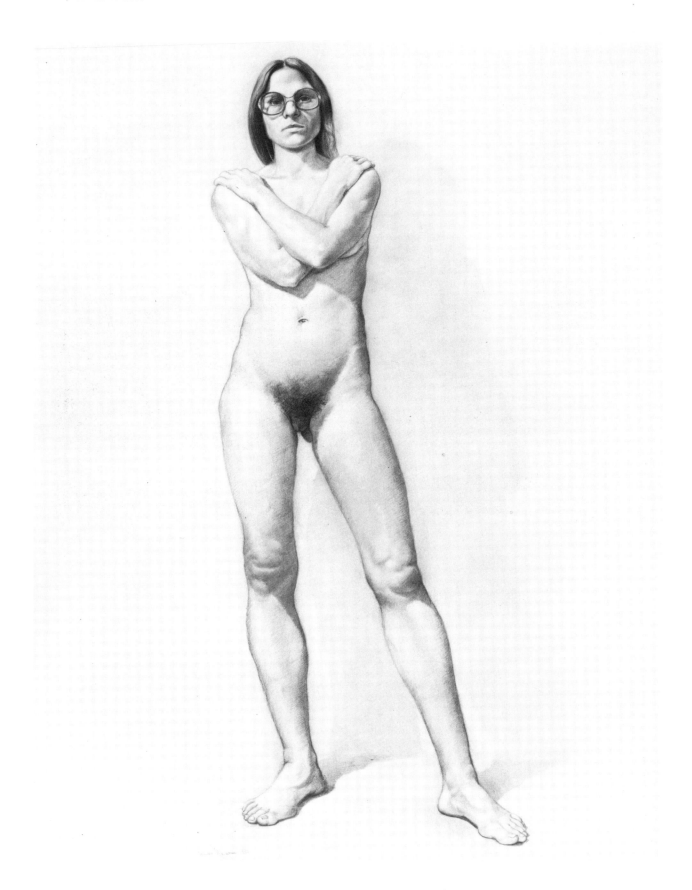

William Beckman
Rainstorm, 1978
Pastel, 40x60 inches
Allan Stone Gallery, New York

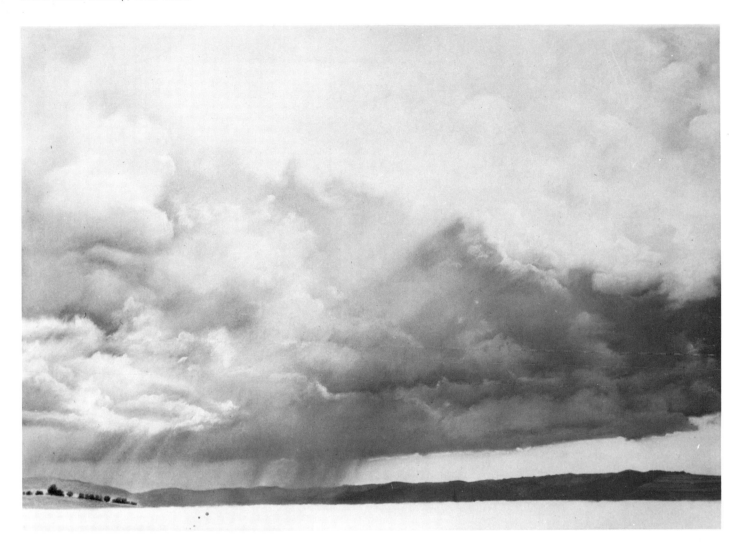

Daniel Lang
Ludlow Street, 1973
Pencil with oil wash, 22x17 inches
Collection of the artist

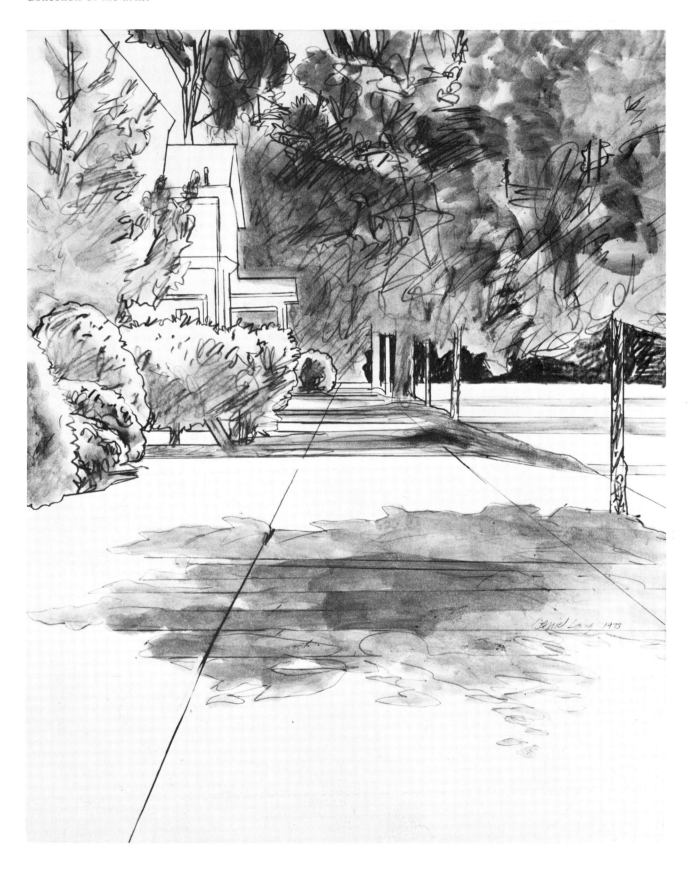

Daniel Lang
Illyria, 1973
Oil and pencil on paper, 27x20 inches
Collection of the artist

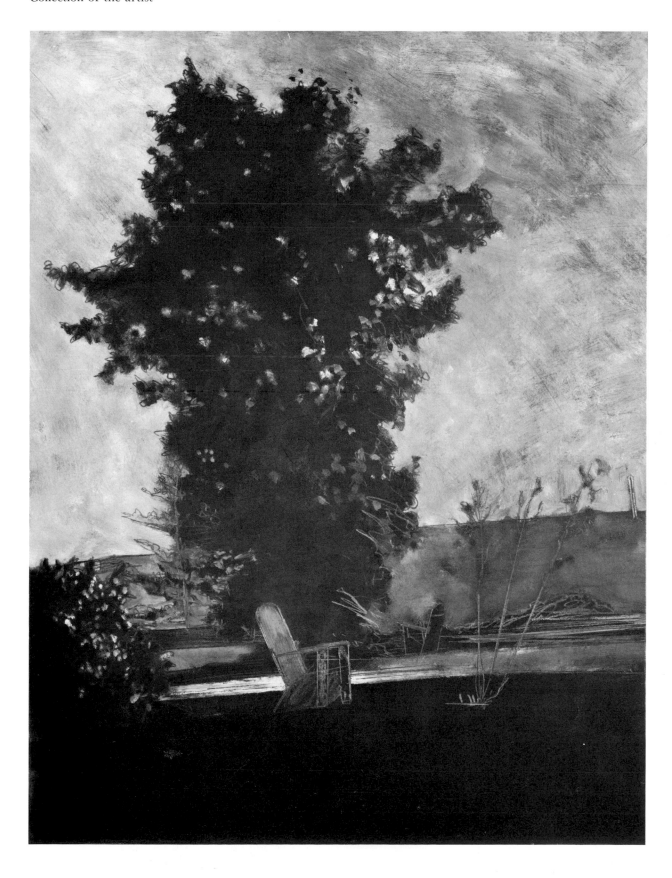

Susan Hall
Don't Blame Me, Blame the Moonlight, 1977
Acrylic on paper, 40x32 inches
Collection Robert Feldman

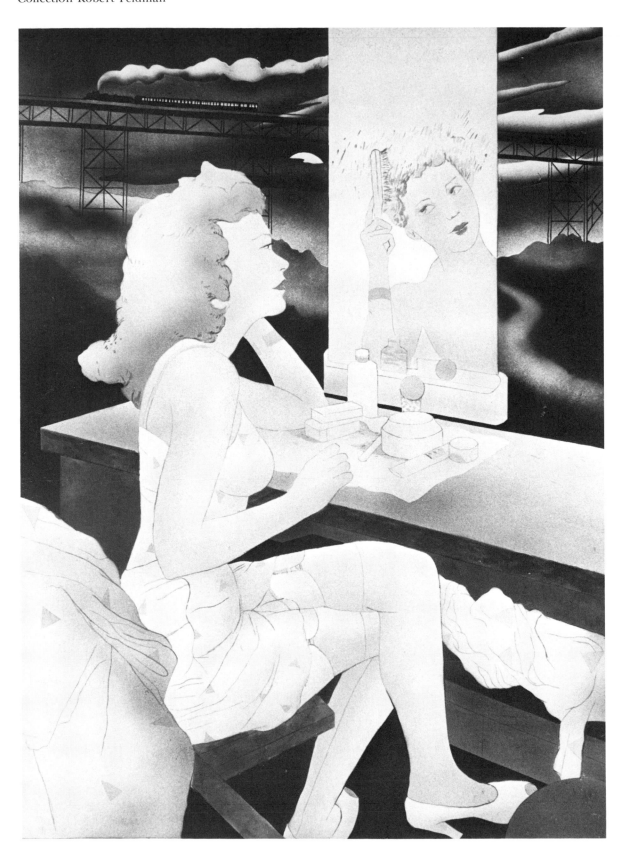

without the protective armor of an assumed role. Hockney astutely renders the famous façade, but penetrates the public identity to depict a guarded and slightly wary person, someone perhaps a bit uncomfortable with the knowledge of Hockney's propensity for getting beneath the public image to reveal the private man.

Willard Midgette's poignant portrait of his wife Sally, and the study of his children, Dameron and Anne, are intimate, pensive, charming, and reflect the deep affections for and understanding of family. Without titles, the relationships are clear. These studies, drawn on toned paper with pencil and charcoal and heightened with white chalk, reflect his interest in illusionistic problems: Dameron's elbow juts beyond the perimeter of the picture, and Sally is framed by the mirror, a reflected rather than direct image with the bedroom interior as background. The portrait drawings illustrate on a modest scale the intellectual and visual scope of his large, complicated trompe-l'oeil constructions.

The small, crisply modeled drawing by Catherine Murphy of Harry Roseman at work on a miniature of Hoboken and Manhattan is an elaborate composition rendered with the precision of a Sheeler drawing. The complexity of the space is intensified by its peculiar amputation and by the multiplicity of parallels created by the figure, modeling stand, chair, vise, and other objects.

Murphy's *Still Life with Pillows and Sunlight,* compared with Valerio's drawings, illustrates the subtle differences in their tightly rendered tonal works: Murphy concentrates on form described by light; Valerio emphasizes the tactile qualities of the objects. As painters, both are remarkable colorists.

The marvelous classical drawings of William Bailey have the specificity of direct observation that marks them as "Contemporary Realist," but the gentle, delicate modeling of the forms and the gracious line give them a timeless air. Building with pale traces of line more akin to silverpoint than pencil, Bailey moves past descriptive fact toward idealized canon. While he is often compared to Ingres, there is a mystery and sensual poetry in his work that moves it toward the realm of Balthus, but it is without the narrative context of the latter's work.

William Beckman's figure drawings are scrupulously direct observations, akin in clarity and incisiveness to the drawings of Holbein and Ingres and the early work of Degas. Many of the figure drawings are constructed by viewing through a string grid (a device used by Van Gogh) and drawing on paper with a grid. (An enlarged grid on a larger ground can be used for transferring the image.)

Beckman's pastel landscapes are much closer in development to painting than to drawing. The pastels are begun from small pencil sketches done on site and later transferred to gessoed museum board by grid. Then, returning to the site and working with pastels sharpened with a razor, Beckman slowly constructs the drawings layer by layer, with frequent sprays of fixative to hold the powdery pigments. These delicately toned and colored landscape drawings maintain a sense of immediacy by expressing the quality of transitory light.

The landscapes of Daniel Lang are immediately believable in terms of the specifics of time, weather, and place. This projection of verisimilitude accounts for their accessibility as images modified by the medium rather than controlled and held in check by the intellect.

Our unguarded ease in accepting Lang's landscapes as accurate descriptions of the real world leads us unsuspectingly into landscapes of the mind. What we believe is a parallel to "reality" is in fact closer to the fabric of dreams. We respond to these landscapes in two ways: to their subjects, as reminders of our own similar encounters with nature; and to the mood they conjure up as parallels to our past experiences.

Lang's drawings have spontaneity; like Diebenkorn in his use of line, Lang uses his medium to parallel the tactile qualities rather than imitate them. Using pencil plus an oil and turpentine wash, which soaks into the paper like a soft grainy stain and can be built up in tonal layers (*Ludlow Street*), Lang has produced many beautiful drawings. The poetic *Illyria,* in opaque oil and pencil, is closer to his paintings except for the powdery quality the oil produces on paper as opposed to its characteristic luster on canvas.

Expressionistic rendering — that is, the distortion of the physical representation to convey an inner reality — has a long tradition with remarkable exponents like Grünewald, El Greco, and the German Expressionists. But of equal import, stemming from a quite different tradition, is expressionistic content: the representation more closely approximates our view of nature, but the content is inverted. The image as a whole is closer to the structure and substance of poetry. Bosch and Goya are the greatest, and perhaps most frightening, progenitors, and Breughel was up to similar tricks. The most striking examples in more recent art would be Max Klinger's cycle of etchings, *The Glove* (1881); the surrealistic novel in collage by Max Ernst, *Une Semaine de bonté* (1934); and the enigmatic works of Balthus. Permission to tread the paths of such excursions is long standing.

James McGarrell is closest to the European tradition of such forays. His beautiful set of twelve watercolors based on the legend of *Beauty and the Beast* is close in tone to the Cocteau film but free of imitation. *Afloat/Alight* (Plate 14) takes full advantage of the medium, with many of the elements, such as the figures in the boat and the landscape, predetermined by the story and others invented in the process or developed from accidents of the medium. The rich, elaborate border complements and frames the image, operating like the embellishments in Persian miniatures. His small pencil drawing, *Native Inventions on Bad Elipses — Temporale* (page 68), from a group of imaginary landscapes, appears to refer to the natural elements of air, earth, fire, and water.

The allegorical montages of Susan Hall are disparate images with personal connotations assembled in a manner that adds up to a surprising and unpredicted metaphor. The process involved in creating the total fabric of her pictures is similar to the process of editing film as defined by Eisenstein — the content is derived from a reading of the separate elements in a context prescribed by the artist.

Hall is interested in the minor, banal events of our real and fictionalized lives. Her components are carefully chosen, and their narrative construction is far from random. *Don't Blame Me, Blame the Moonlight* has the romantic, nostalgic mood of an old forties' tune. The woman at her dressing table drifts into reverie, and the wall opens up to a moonlit landscape as an old passenger train steams through the night across a high bridge. *Desert Roses* (Plate 15) is a dreamlike enigma complete with turbaned Arabs gazing across the sand peninsula toward the pyramids in the background. Palm trees are impossibly planted in the water, and bright red roses — closer to those in a gardening catalogue than in a Redouté print — climb the edges. The still blue water appears to reflect twilight stars. It is a puzzling landscape that persuades us to set aside our reason and believe, as we once did as children, in the plausibility of myths.

Painting and magic have many parallels, the most obvious being manual dexterity and the direction of vision employed in combination to produce an illusionistic climax. Ellen Lanyon, originally from Chicago, who has shown an aesthetic inclination toward surrealism and fantasy in the past two or three decades, has dealt quite literally with themes from magic in her paintings, prints, and drawings. She draws in a style reminiscent of turn-of-the-century illustrations and chromolithographs. *The Birds Fly Home* is a large pencil drawing of the three stages of a magic feat. It is crisply rendered: the egg in the cage, the covered cage, and the last stage, the egg hatched and four birds flying from the open door. Based on a specific trick, it climaxes in a fantasy of her own making.

A more recent drawing, *One Way to Quarter a Pear,* depicts a pear tree branch, fruit, leaf, and flower, on a page similar to those in old botany books and herbals. The drawn page is torn at the top, revealing the hand of a magician holding a match that will burn the string suspending the pear above two crossed knives, which will quarter it as it drops. And thus she moves from botanical and zoological facts to fantasy.

Like Ellen Lanyon, Richard Haas borrows stylistically from his nineteenth-century counterparts. His cityscapes appear to have much in common with the urban Photo-Realism of Richard Estes, Robert Cottingham, and John Baeder, but are closer to the anonymous graphic artists of the past who rendered bird's-eye views of cities, or to artists like John Taylor Arms and Samuel Chamberlain, who had a documentary intent. Haas is a traditional artist, but also an artist in step with his time.

Some of his works have the look of architects' renderings, which is not accidental, for Haas has learned their skills, employs many of their devices, and has a deep, broad knowledge of architecture, past and present. His watercolors, such as *View of 57th Street* and *18th Street and Broadway,* regardless of their finesse and authority, are only part of Haas's oeuvre, which is much more diverse than that of the other painters of the urban landscape. He is well known for his convincing trompe-l'oeil murals, both exterior and interior, which are perfectly fused to the architecture.

In contrast to Haas, John Moore in his cityscapes emphasizes formal problems of composition and the atmospheric effects of light and space.

Ellen Lanyon
The Birds Fly Home, 1971
Pencil, 48x48 inches
Richard Gray Gallery, Chicago

Ellen Lanyon
One Way to Quarter a Pear, 1979
Colored pencil and watercolor on tinted paper,
44x30 inches
Odyssia Gallery, New York

Richard Haas
View of 57th Street, 1978
Watercolor, 26x33¼ inches
Brooke Alexander, Inc., New York

Richard Haas
18th Street and Broadway, 1978
Pencil and watercolor, 28^{7}/$_{16}$x21¼ inches
Brooke Alexander, Inc., New York

John Moore
Cityscape, 1978
Watercolor, 24½x10 inches
Fischbach Gallery, New York

John Moore
Pink Flower Glass 9, 1975
Watercolor, 22x30 inches
Fischbach Gallery, New York

Yvonne Jacquette
Black Pastel, 1979
Pastel on Swiss vellum, 37¾x74 inches
Brooke Alexander, Inc., New York

Janet Fish
#87, Green Grapes, 1979
Pastel, 28½x25¼ inches
Robert Miller Gallery, New York

Stephen Posen
Untitled, 1973
Graphite, 40x32 inches
Collection of the artist

Barnet Rubinstein
Still Life with Pineapple, Grapes, Pears, Crabapples, and Straw-berries, 1979
Graphite and colored pencil, 22½x30³/₁₆ inches
Collection J. and R. Davidson, Boston

Don Nice
Bk I/pp XIII, 1979
Watercolor, 30x22½ inches

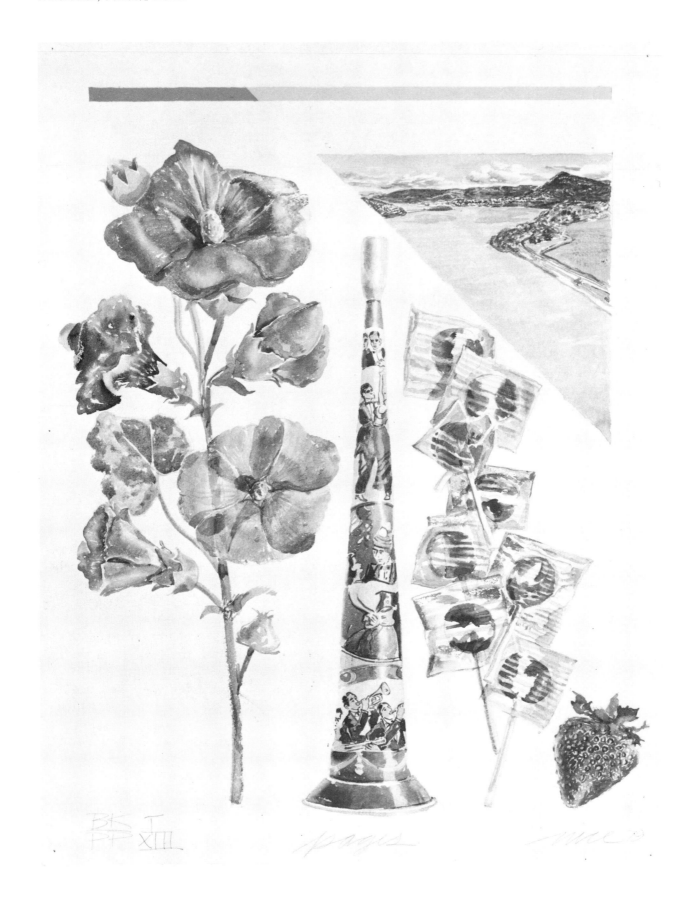

Don Nice
Western Series Hat, 1970
Pencil, 12½x20 inches
Nancy Hoffman Gallery, New York

Depicting views from and framed by windows, these directly painted water-
colors are closer in some ways to nineteenth-century naturalism — the early
work of Corot, for example — than to today's urban realism. The forms
are generalized with the emphasis on the complexity of the abstract pat-
terns and shapes of the city, modeled by light and cast shadows.

The elements of Moore's beautiful still lifes are carefully arranged in
space like actors on the stage. His choice of objects for their color, tactile
interest, and transparency owes no more to accident than does the place-
ment of objects on a Japanese screen. He is also fascinated with the transla-
tion of transparency and opacity through the medium of watercolor, which
he achieves with great economy.

The aerial views by Yvonne Jacquette move much closer to abstraction
in both rendering and subject matter. Her large *Black Pastel* depicts the
night lights of a city converted to a jewel-like fantasy when seen from
height and in darkness. Drawing with a buildup of choppy marks, a tech-
nique that has a functional parallel to pointillism, she flattens the forms to
patterns, defining their edges by line.

For more than a decade Janet Fish has displayed a preoccupation with
light falling on and passing through transparent and translucent objects,

107

and with rambunctious shifts in scale. Her earlier still lifes were more orderly and static than the recent works, the objects resting on and reflected in glass sheets. A beautiful colorist, she maintains a clean, impressionistic quality, although her recent drawings have an expressionistic edge.

The pastel *#90, Two Peaches* (Plate 16) reflects the tonal turn and tactile complexity of Fish's recent work. The relationships of the objects are based on the harmonious and complementary qualities of their local color, as well as on shifts among transparency, translucency, and opacity. Such works, with their subtle transliteration of light and color, are clearly the result of direct observation.

The large, mysterious, and illusionistic still lifes of Stephen Posen begin as constructions on his studio wall that serve as direct models for his paintings. Functioning as trompe-l'oeil, they are immensely successful because of his skills as a draftsman, painter, and highly astute observer of the fluctuations of local color.

Posen's drawings have something of the mysteriousness of the drawings of drapery by Dürer and Leonardo da Vinci and reflect similar preoccupations. The drapery is at once abstract and sculptural, hiding the recessions and protrusions of the forms beneath, which in turn dictate its shape. Posen draws with the simplicity and authority of a classicist.

In sheets of still life, Barnet Rubinstein lines up objects like an inventory of machine parts or the serialization of a military move; they float on the white paper, each object, each fruit, cactus, compote, rendered with the crispness of an engraving. The impetus appears to lie in the pleasure of recording casually the light, shape, and forms of certain objects that have struck his fancy.

The objects in watercolors by Don Nice are also rendered on large white sheets without backgrounds, but they take on an emblematic quality. In the choice of objects and their associations, Nice is closer to Thiebaud than to Rubinstein, but the names of the objects read like a list of lost remnants of childhood: water pistols, bubble gum, candy kisses, whistles, fruits, and an immense repertoire of zoological specimens (Plate 17). As Bachelard has reminded us, "Poets convince us that all our childhood memories are worth starting over again."[3]

1. Lawrence Durrell, *Balthazar* (New York: E. P. Dutton, 1961), p. 14.
2. "The Most Living Artist," *Time*, Nov. 29, 1976.
3. Gaston Bachelard, *The Poetics of Reverie* (Boston: Beacon Press, 1971), p. 125.

13 Red Grooms

Self-Portrait, 1974
Watercolor and pencil, 25½x22¼ inches
Collection Robin Pell, New York

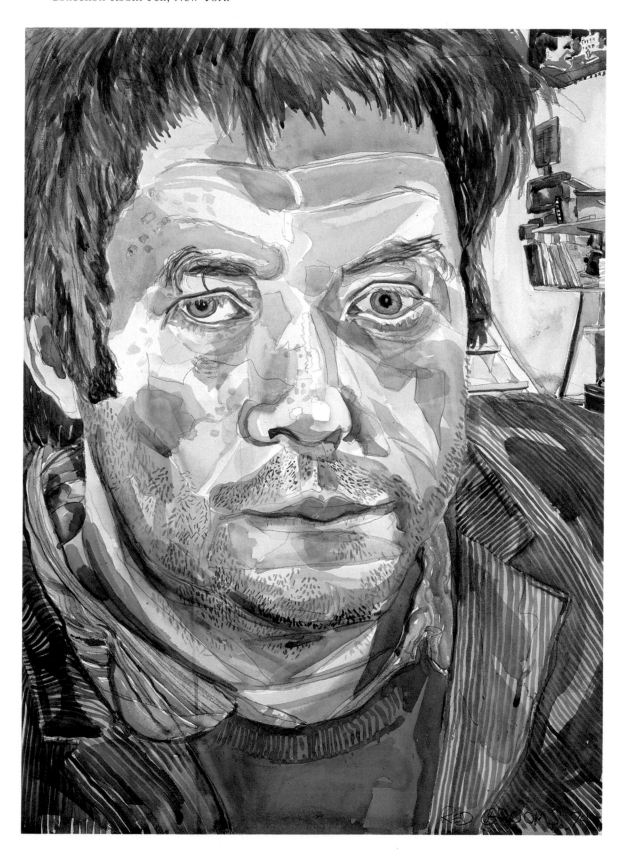

14 James McGarrell
Afloat/Alight, 1979
Watercolor, 30x22 inches
Clarke-Benton Gallery, Santa Fe, New Mexico

15 Susan Hall

Desert Roses, 1979
Acrylic, 38½x46 inches
Collection Miami Branch of the Federal Reserve Bank

16 Janet Fish

#90, Two Peaches, 1978.
Pastel, 20x27 inches
Robert Miller Gallery, New York

17 Don Nice
Bk I/pp XIV, 1979
Watercolor, 30x22½ inches
Nancy Hoffman Gallery, New York

18 Patricia Tobacco Forrester
Under the Coulter Pine, 1976
Watercolor, 76x40 inches
Kornblee Gallery, New York

19 Susan Shatter

Cycladic Dome, 1978
Watercolor, 29½x44½ inches
Collection J. and R. Davidson, Boston

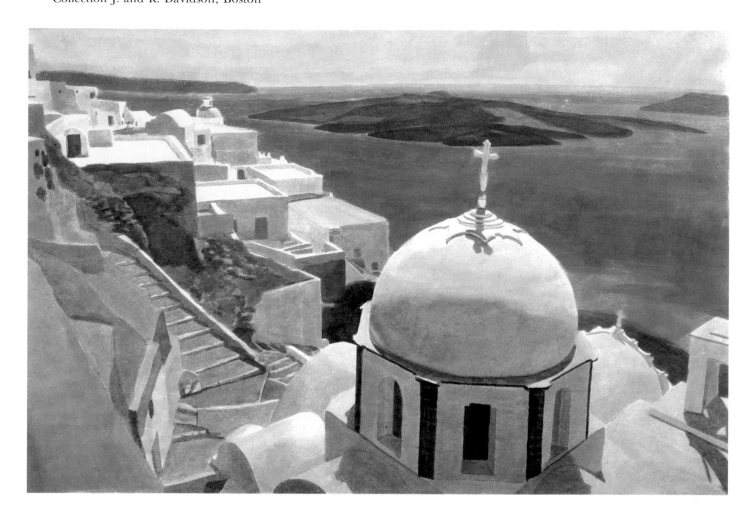

20 Bill Sullivan

Plaza #2, 1979
Pastel, 42x47 inches
Kornblee Gallery, New York

21 Carolyn Brady

Blueberry Jam, 1979
Watercolor, 39x28½ inches
Nancy Hoffman Gallery, New York

22 Sondra Freckleton

Wheelbarrow Harvest, 1979
Watercolor, 41½x41½ inches
Fendrick Gallery, Washington, D.C.

23 William Allan
Albacore, 1979
Watercolor, 24x38 inches
Odyssia Gallery, New York

24 P. S. Gordon,
Royal Doulton, Narcissus, Chinese Silk Kite, 1977
Watercolor, 31¼x22 inches.
Collection of Mr. and Mrs. R. R. Bastian, III

V

Fanatic Draftsmen

This is the truth of the pervading intricacy of the world detail: the creation
is not a study, a roughed-in sketch; it is supremely, meticulously created,
created abundantly, extravagantly, and in fine.

Annie Dillard, *Pilgrim at Tinker Creek*[1]

One of the most fascinating aspects of figurative art in the seventies is the extremes to which some of the younger artists have pushed the pursuit of drawing and watercolor. Their work defies anticipations based upon knowledge of the traditional uses of these media.

Most of the artists of this group discussed here produce only drawings and watercolors (the exceptions are Martha Mayer Erlebacher, William Allan, and Susan Shatter). While working with materials and techniques that best fit these media, they have pushed the boundaries of drawings and watercolors in two directions, sometimes simultaneously.

The first is seen in the work of artists like Susan Shatter, Patricia Tobacco Forrester, Bill Sullivan, Ann McCoy, and Carolyn Brady. The scale of watercolors and drawings is enlarged to the size of traditional easel paintings or beyond, to the proportions more typically associated with recent abstract painting. These works are far from being enlargements of bin-sized drawings; scale and medium harmoniously accommodate their imagery.

The second direction is seen in the work of William Allan, Juan Gonzales, Martha Mayer Erlebacher, Patrick S. Gordon, Joe Nicastri, and Theo Wujcik. Scale is more traditional, but the degree of development and detail is pushed to extremes, although traditional materials such as pencil, pastel, watercolor, and silverpoint are employed.

Such ploys could be considered affectation if the considerations of scale and/or media were less integral to the artists' demands; in fact, it is impossible to imagine their intentions transcribed to painting, and there is no conflict between their intent and their medium.

Look . . . at practically anything [in nature] — the coot's feet, the mantis's face, a banana, the human ear — and see that not only did the creator create everything, but that he is apt to create *anything.* He'll stop at nothing.

Annie Dillard, *Pilgrim at Tinker Creek*[2]

The deep-fathomed fantasies of Ann McCoy, densely populated by a rich variety of phantasmagoria, crustaceans, flora, bizarre creatures selectively trapped at a primeval stage of development to serve strange functions, unfold again to reveal planets, meteors, comets moving through a galaxy of perpetual night. Sea and space, our two most unfamiliar and inhospitable regions, collide in a cluttered montage of disparate associations. Ann McCoy is like an Old Testament prophet with a proclivity for Jungian analysis reporting on events occurring in an aquarium that has been lost in space. The messages are difficult to decipher, but the images sent back are great.

121

On a scale that rivals color-field paintings and hanging from grommets like tapestries, these mammoth drawings are done with colored pencils on paper sized with acrylic and mounted on canvas. They are assembled from an assortment of photographs and reproductions gleaned from *National Geographic,* science books, and the archives of oceanographers, material that is blown up on the canvas-backed paper with the aid of an opaque projector and assembled with dreamlike abandon; the creatures seem to gather at the surface, as though attracted by the bright light of the projector, to be traced off in the delicate pastel colors of a late Bonnard.

Patricia Tobacco Forrester's flayed, contorted images, such as *Under the Coulter Pine* (Plate 18) and *Flowering Ash,* are done with very wet colors on sheets of butted paper the size of large doors. The images are slightly disjointed at the seams, distorted as if by subtle warps, like objects seen through panes of old glass, and stand as twisted relics of our primeval past.

In contrast to Ann McCoy's deep-sea fantasies and the deep-spaced vistas of Susan Shatter, Forrester's spaces are close and cluttered. Where a glimpse of sky or space appears, it is at once closed off, its accessibility blocked by the intricate web of branches. A notable technical distinction is that Forrester, unlike Shatter and McCoy, works directly from nature rather than using photographic source material; she does not even have a studio. Only minor touch-up work is done inside.

The large, panoramic landscapes of Susan Shatter are painted with watercolor on a highly absorbent paper that is intolerant of false moves (Plate 19). They are worked up in the studio from a combination of information — direct sketches, photographs, and slides. The carefully controlled and modulated tone and color describe geology, deep, clear aerial space, and specifics of light. Where Forrester records the glut of growth, Shatter records the wear of weather on the landscape.

Viewed from a distance, these large panoramas seem to have the specificity of a Thomas Moran painting or of the long-exposure nineteenth-century photographs of the American Southwest by W. H. Jackson, T. H. O'Sullivan, and C. E. Watkins; but observed up close, they dissolve into wet, interlocking, abstract shapes of carefully modulated colors and tones similar to those in the paintings of Augustus Vincent Tack.

The women glimpsed in the large color drawings of Bill Sullivan call up the characters of an early, glittering chapter of a Jean Rhys novel (Plate 20). They are engaged in glamorous trivialities, always poised, frozen in act or gesture. He records a world that is usually encountered vicariously through novels, magazines, and movies. These large drawings are quickly rendered from the artist's own slides projected on large sheets of white paper. The images are rapidly traced and tinted with pastel, colored pencils, watercolor, and acrylic. The rich lights and darks, ornately rendered patterns and surfaces, belie the economy of means by which they are obtained. So clearly and articulately summed up are specific details, accoutrements, physiognomy, and personality that we would recognize Sullivan's women browsing at Bendel's.

Carolyn Brady seldom strays beyond the perimeters of her home for the source material for her lush, extravagant watercolors. Her interiors and

Ann McCoy
Dragons for John O'Leary, 1979
Colored peencil on paper with acrylic ground, mounted on
canvas, 90x60 inches
Brooke Alexander, Inc., New York

Patricia Tobacco Forrester
Flowering Ash, undated
Watercolor, 80x52 inches (four panels)
Kornblee Gallery, New York

Susan Shatter
Virginia River, 1979
Watercolor and pencil, 37¾x49⅜ inches
Collection Lehman Brothers, New York

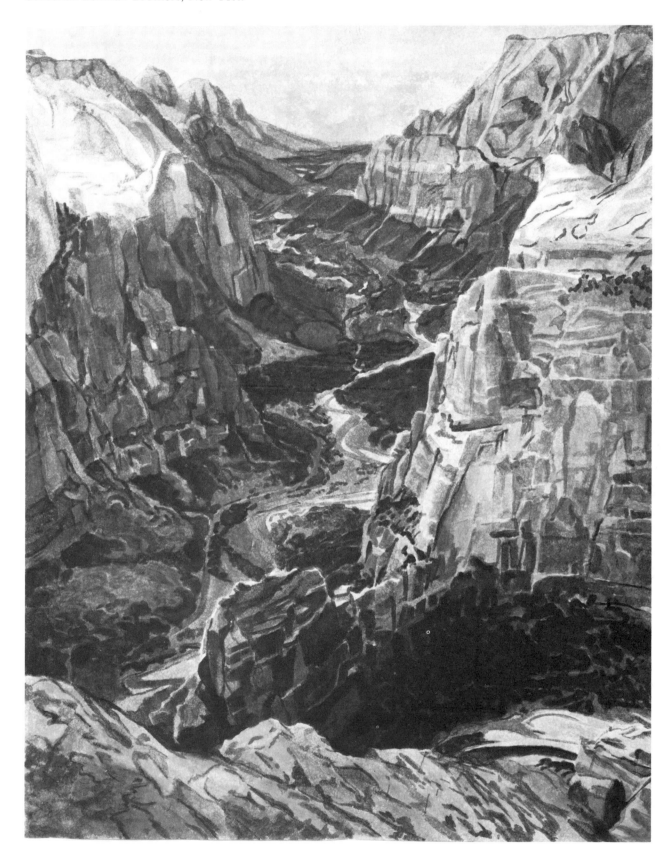

Bill Sullivan
Brunette, 1978
Oil crayon and colored pencil, 59x41¾ inches
Kornblee Gallery, New York

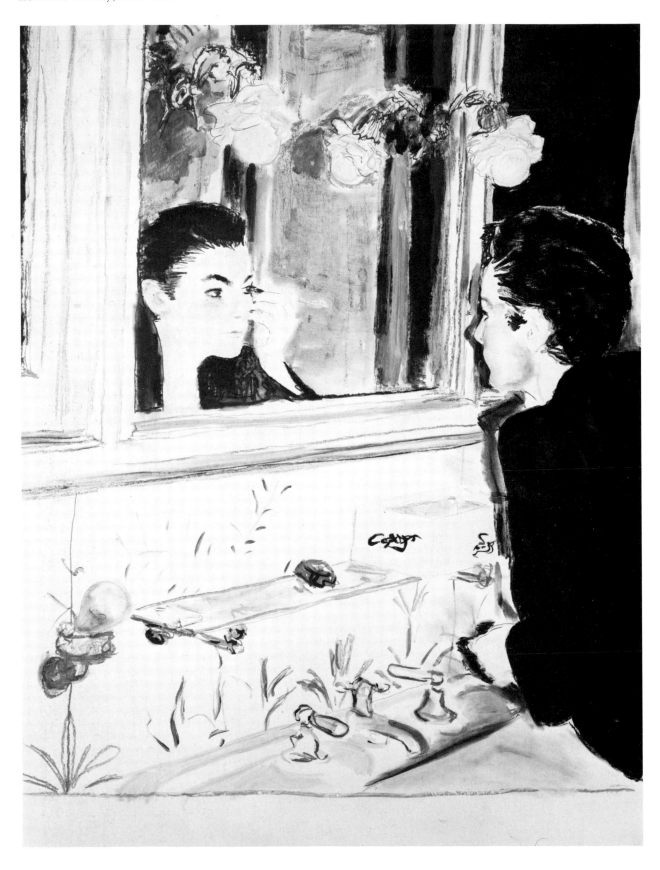

Carolyn Brady
Fishbowls, 1977
Watercolor, 41x26 inches
Nancy Hoffman Gallery, New York

Sondra Freckleton
Trailing Begonia, 1979
Watercolor, 46x28½ inches
Brooke Alexander, Inc., New York

William Allan
Rainbow Head — Four Hours from Life — Mill Valley, 1972
Watercolor, 24x29½ inches
Odyssia Gallery, New York

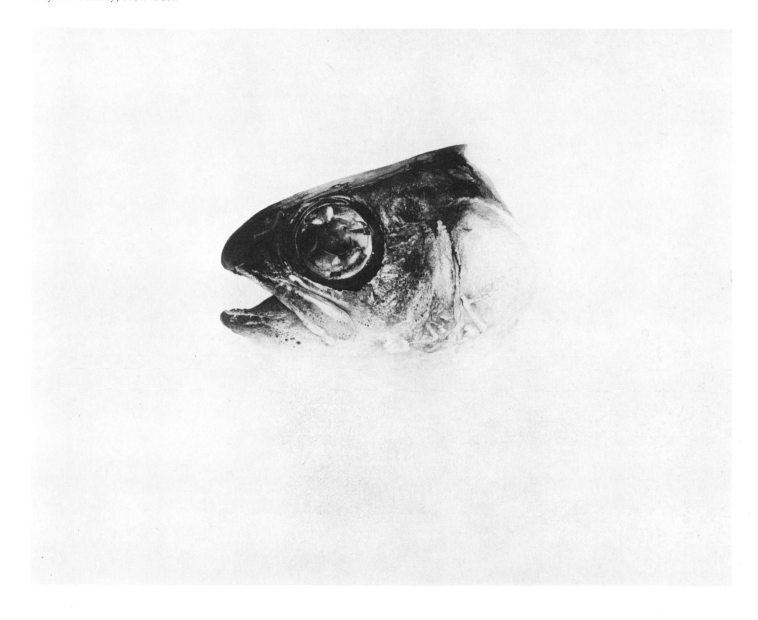

Martha Mayer Erlebacher
Homage to Bacchus, 1975
Stabilio and watercolor, 22x30 inches
Robert Schoelkopf Gallery, New York

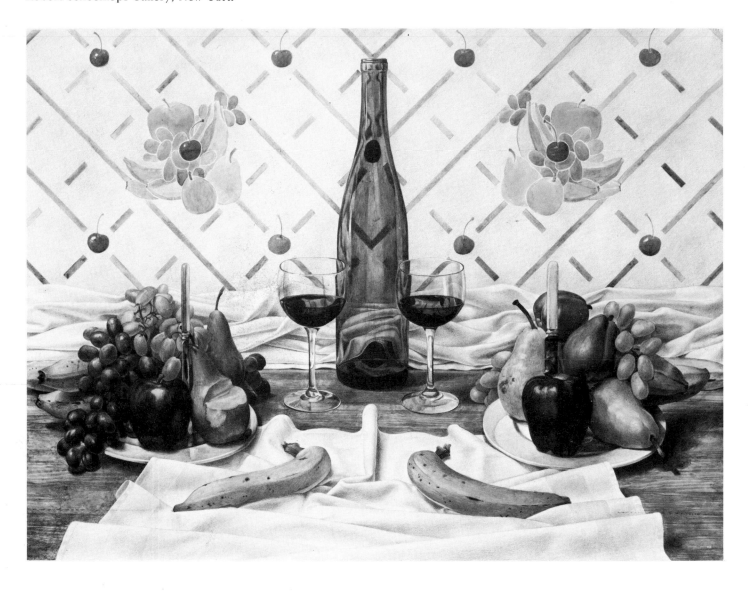

Martha Mayer Erlebacher
Alexis, 1976
Pencil, 13½x11 inches
Robert Schoelkopf Gallery, New York

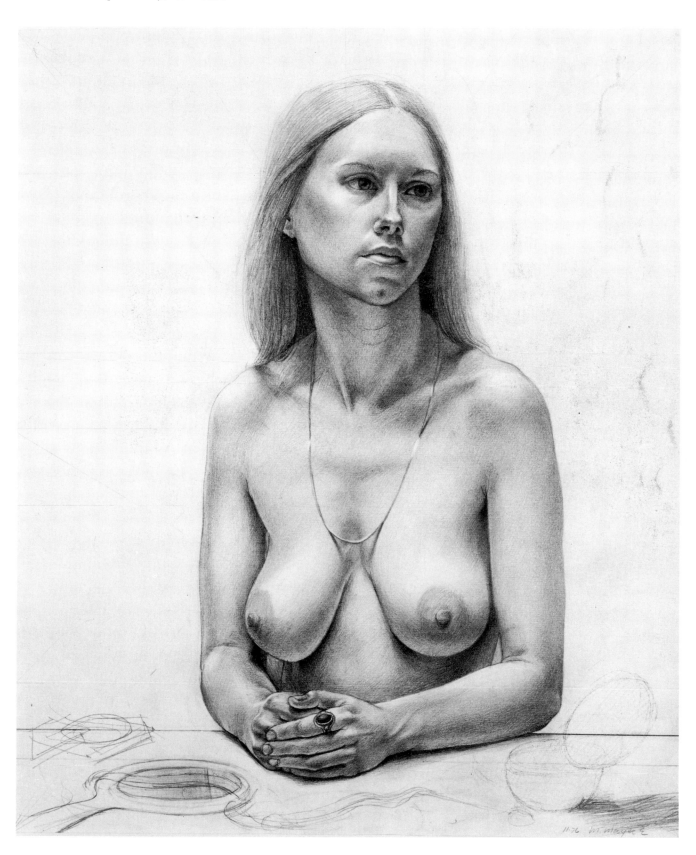

Theo Wujcik
Jasper Johns, 1979
Silverpoint, 20x26 inches
Brooke Alexander, Inc., New York

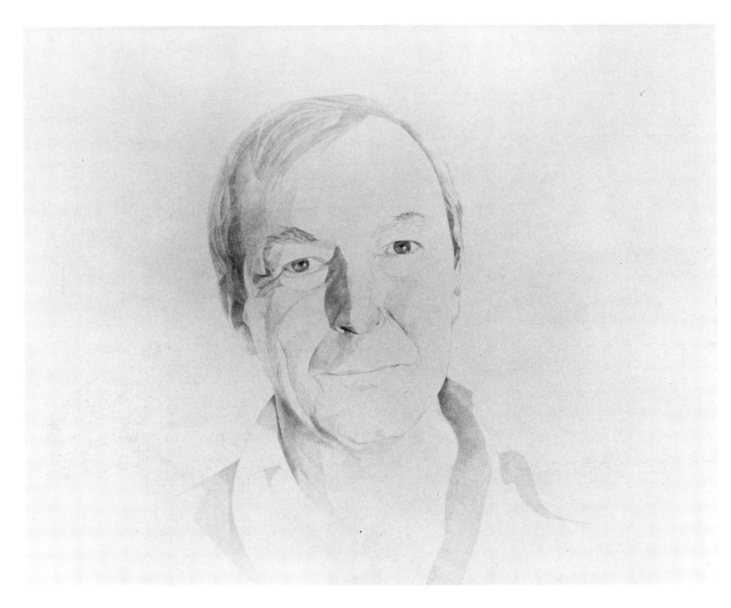

Theo Wujcik

Jasper Johns, 1980
Graphite lines, ebony stomping, on three attached sheets,
37½x60 inches overall
Brooke Alexander, Inc., New York

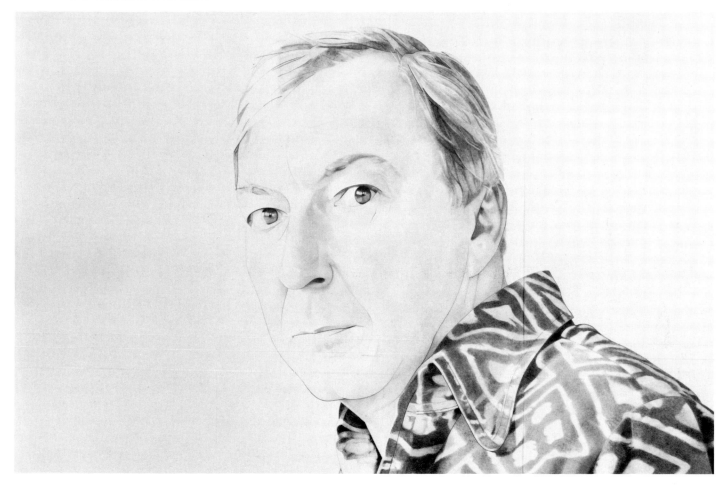

Joe Nicastri
Three Arrangements, 1975
Pencil on gray graphite ground, 38x38½ inches
Nancy Hoffman Gallery, New York

Juan Gonzales
Sara's Garden, 1977
Graphite, 22x18 inches

Juan Gonzales
July 11, 1974
Colored pencil and pastel, 25½x19½ inches
Nancy Hoffman Gallery, New York

still lifes, rendered with great technical finesse, tell a great deal about who she is through the way she lives.

Worked up primarily from color prints of her photographs, these elaborate, sharply focused scenes with their lavish patterns and rich colors evoke the inhabitants of these interiors like a trace of perfume. *Blueberry Jam* (Plate 21) and *Fishbowls* retain that quiet mystery inherent in the lingering presence of a person who has momentarily left the room.

In sharp contrast with Brady's work, the highly developed watercolors of Sondra Freckleton are carefully constructed and composed, and they are painted directly from the subject. Freckleton's move from abstract sculpture to realist painting was uncalculated but a logical evolution. Her watercolors map the seasonal changes of her vegetable and flower garden and document her enormous collection of quilts and bric-a-brac from the local flea markets, but they are constructed like abstract sculptures. In *Wheelbarrow Harvest* (Plate 22), the barn-red wheelbarrow sits filled with produce like a cornucopia, with the container serving as a gentle reminder that nature's abundance is cultivated by hard work.

There is an elegant, formal grace in Martha Mayer Erlebacher's meticulous and patiently resolved drawings and watercolors that was lacking in her earlier abstractions. They produce a magic completely enclosed within their perimeters that is of our time, but has reference to the symbolic and idealized images of the Quattrocento. It is a feat she achieves without lapsing into imitation.

Directly observed, these drawings are carefully planned constructions, painstakingly composed, but they are freed from rigidity by the subtle marks of nature. The feast of fruit and wine, *Homage to Bacchus,* mirrored from the center like a Rorschach blot and parodied in the geometrical wallpaper with punctuations of cherries and patterns of the same fruit, harks back to the formal concerns and contrivances of art of an earlier time.

The sweet, sensual *Alexis,* with head tilted like Botticelli's Venus, is composed on a geometrical grid. She is seated, perhaps at a dressing table, with mirror and makeup incompletely rendered. The image fluctuates between the real and the idealized, antiquity and modernity, stranding the viewer without a definite fix in time and reality. The woman floats like an apparition, a fragment from a dream. The rich diversity of contemporary figurative art in medium, expressive possibilities, and treatment of a theme is clear when one compares this Erlebacher with Bill Sullivan's *Brunette,* Susan Hall's *Don't Blame Me, Blame the Moonlight,* and Willard Midgette's *Sally.*

William Allan is noted for large, personal allegories like *Self-Improvement,* a clipper ship at sea towing an enormous apple core, its wind-filled sails inscribed with slogans. Earlier in his career, Allan learned the difficult technique of egg tempera, which requires extreme patience, for the image must be built slowly, in succeeding layers of transparent color. This layered construction of very transparent color is employed with great finesse in watercolors such as *Albacore* (Plate 23), and *Rainbow Head.*

A dedicated naturalist and highly skilled fisherman, Allan does not deal in generalities in these watercolors. Each is a specific portrait, down to the last marking and scar, titled with reference to streams and creeks; he covers sheets with drawings of eyes, denoting time out of the water and details of body marks.

Having studied painting, Theo Wujcik moved into graphics and trained as a lithographer at Tamarind. His encounter there with the painter Billy Al Bengston was an event of importance to Wujcik, who commemorated it with a drawing of Bengston that was the first of the silverpoint portrait series of painters-printmakers that followed. Many were made possible by a grant from the National Endowment for the Arts that allowed Wujcik to travel with a photographer, making black-and-white photographs to use as source material for his drawings.

His earlier silverpoint drawings were done on a paper coated with gesso that was thin enough to allow tracing of a line drawing underneath; but the more recent work is done on cream-colored paper with a clay ground (a ground is necessary for the hard silver as opposed to pencil or graphite) that is too opaque for tracing. This problem has led to the use of a paper template, which verges on the intricacy of an Indian shadow puppet. These highly articulate and extremely delicate portraits successfully fuse appearance and personality while de-emphasizing expressive aspects.

P. S. Gordon
Lilliputians, 1979
Watercolor, 30x22 inches
Collection Bruce G. Weber, Tulsa

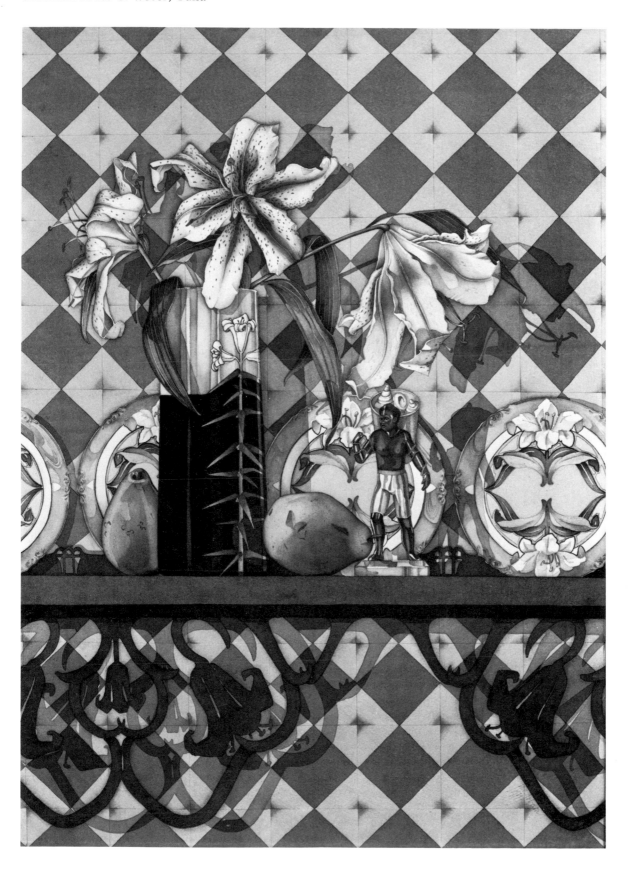

The monochromatic drawings produced by Joe Nicastri in the mid-seventies, such as *Three Arrangements,* are rendered with the crisp precision of an Ingres, but have a quality of inscrutability more akin to the early Mondrian *Chrysanthemum.*

Nicastri's drawing procedure is as elaborate as the images are illusive. The dried flowers are carefully arranged and taped to the wall, then drawn on paper prepared with gesso and graphite and with a patina like an ancient wall. The image is delineated by a series of minute tattooed pencil dots rather than line, which results in an apparition of flowers that seem to have floated up through the gesso or to be on the verge of being worn away.

It is a rare experience to encounter an artist like Juan Gonzales, who trades in apparitions (what Jung called the secret soul of things), especially when he has the instinct to keep the works small, making the experience close and private; when he has the heart of a poet, giving the works authenticity and resonance; when his great finesse is coupled with abundant patience, giving them accuracy and meticulous information. His images are interior worlds seen with exterior clarity, fantasies with factual specificity. These unrelated objects, drawn with needle-sharp colored pencils, pastels, and occasional tints of watercolors gathered from a conglomerate of direct and photographic information, merge without collision or abrasion as enchanting myths.

P. S. Gordon supports himself by painting commissioned portraits and through the sale of his still-life paintings. Both the portraits and still lifes are ornate and lavishly patterned watercolor compositions. The portraits are unquestionable likenesses, but they are highly flattering, for as Goya, Velazquez, and Klimt have shown, physical shortcomings can be minimized by seducing the eye with aspects such as showy costumes and ornate patterns. Successful portrait painting has always been a catered performance.

Living in a small apartment as laden with bric-a-brac as his watercolors, Gordon rotates these objects regularly through the paintings. The objects are loaded with nostalgic value, visual delight, and personal references, and are ever-changing in their relationships with other objects, colors, and patterns. The still-life paintings, which are reminiscent of the watercolors of Charles Rennie Mackintosh (whose work, except for the furniture designs, was not familiar to the artist), are drawn from life, but start with one object on a shelf parallel to the picture plane, drawn carefully in line with pencil (Plate 24). Other pieces are added, one at a time, their relationships arranged on the paper rather than on the shelf. There are shifts in the relative scale, and when the drawing is completed, development with watercolor begins. It is deliberate and attentive in the description of surfaces. Patterns and colors for the backgrounds are made up, as in the ornamental shelves or cabinets on which the objects rest, further to complement and enhance the ambiance of each particular still life.

1. Annie Dillard, *Pilgrim at Tinker Creek* (New York: Harper's Magazine Press, 1974), p. 137.
2. *Ibid.,* pp. 137–138.

Juan Gonzales
La Misa Blanca, 1976
Colored pencil
Nancy Hoffman Gallery, New York

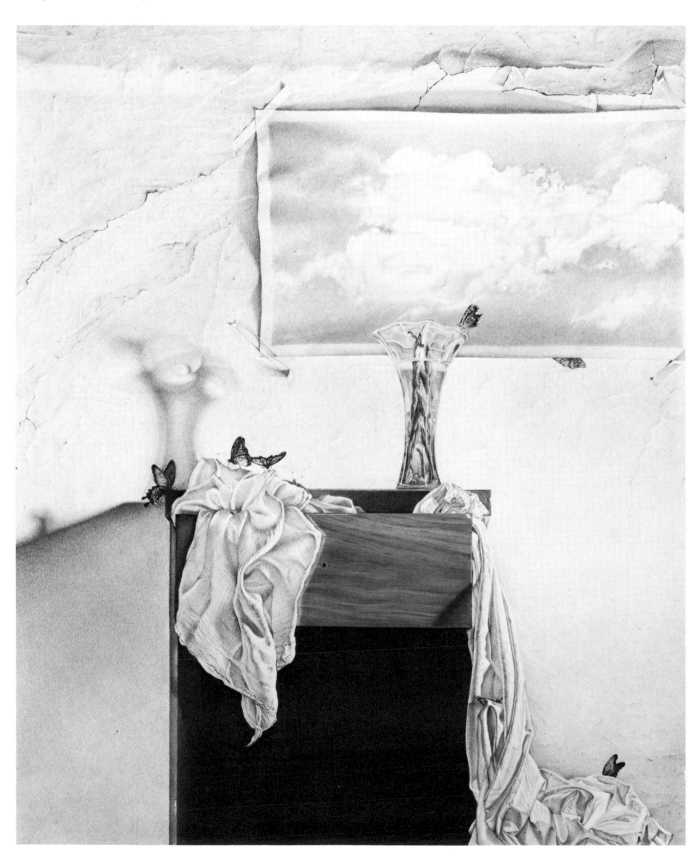

Some Concluding Thoughts

Several months ago in the back room of the Allan Frumkin Gallery, I encountered a Pearlstein line drawing from the early sixties and was surprised at its similarity to the pencil and ink figure studies of the same period by Diebenkorn. Looking at the drawing, I asked Philip about his loose, painterly work from that period, and he remarked, "They looked very tight at the time." The situation has changed drastically over the past two decades, bringing with it a climate open not only to the experiments of the minimal and conceptual artists but also receptive to the contemporary Realists.

Significantly, there are artists who are impossible to characterize but who have demonstrated a unique and deeply personal vision. Artists like Lucas Samaras, Rafael Ferrer, William Wiley, and Roy de Forest have opened new avenues for the possibilities of anthropomorphic explorations. Discussing the situation as it has evolved over the past decades with Allan Frumkin, I came to these conclusions: draftsmanship as an act of examining and recording with high degrees of verisimilitude was so de-emphasized in the fifties that both the skills required and the appreciation of them appeared to atrophy. But drawing was returned to a more traditional role and level of skill by the self-imposed and ever-increasing demands of the first-generation Realists. The drawings of such artists as Pearlstein, Thiebaud, Leslie, and Beal helped to create and educate a new and younger audience while simultaneously influencing the developing second generation of Realist artists.

The connoisseurship of drawings and watercolors — on the part of artists, collectors, and art public — has rapidly regenerated, and the expressive possibilities of figurative drawing have expanded in many equally convincing directions. The interwoven relationships of artists with one another and with the art world have stimulated an increasingly healthy climate and opened many avenues. One can only surmise that the decade to come will be extravagantly diverse and unpredictable.

141

Illustrations in Black and White

Color Plates